Bicycles

LE BICICLETTE

Fermo Galbiati

Nino Ciravegna

CHRONICLE BOOKS

SAN FRANCISCO

P9-DNP-445

First published in the United States of America in 1994 by Chronicle Books.
Copyright © 1989 by BE-MA Editrice.
All rights reserved. No part of this book may be reproduced in any form without written
permission from Chronicle Books.

Printed in Hong Kong.

ISBN: 0-8118-0750-9

Library of Congress Cataloging in Publication Data available.

All the objects presented in this book have been kindly lent by the Galbiati Museum in
Brugherio, Italy.

Caption translation: Joe McClinton
Photography: Cesare Gualdoni
Cover photograph: Cesare Gualdoni
Cover and text design: Dana Shields, CKS Partners, Inc.
Production: Robin Whiteside

Distributed in Canada by Raincoast Books
112 East Third Avenue
Vancouver, B.C. V5T 1C8

10 9 8 7 6 5 4 3 2 1

Chronicle Books
275 Fifth Street
San Francisco, California 94103

The Bicycle

*T*he bicycle was the first vehicle built by man for faster, self-propelled movement. Since the first *célérifère* of 1791, made entirely of wood and devoid of pedals, the bicycle has undergone a constant evolution.

The very uncommon pieces in this collection represent the fundamental stages in the development of the two-wheeler: from the introduction of brakes, pedals, and the chain—with its ingenious gears—to sprung saddles and an endless range of accessories. These examples provide both important documentation and exhaustive illustration of the genius of bicycle craftsmen through the years. Improvements contributed from all over the world have helped make this simple vehicle as useful as it is popular.

A look at these fascinating models, all of them original and in working order, brings to mind the periods and costumes of the past—and a recollection of events that were sometimes dramatic, but more often delightful.

Célérifère

*B*uilt late in the 18th century, this is one of the first *célérifères* (from the Latin meaning "I carry fast")—just a rosewood bar carved into the shape of a crocodile, with two iron-rimmed carriage wheels. There is no steering mechanism; to propel it, you push with your feet.
Detail: The crocodile head.

Celerifero

Costruito alla fine del'700, è uno dei primi celeriferi (dal latino: io porto veloce). Si tratta di un semplice travetto di legno di rosa, scolpito a forma di coccodrillo, con due ruote da carrozza cerchiate di ferro. Non ha sterzo, e per avanzare si spinge con i piedi a terra.
Nel particolare: la testa del coccodrillo.

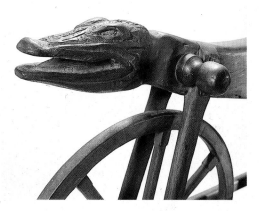

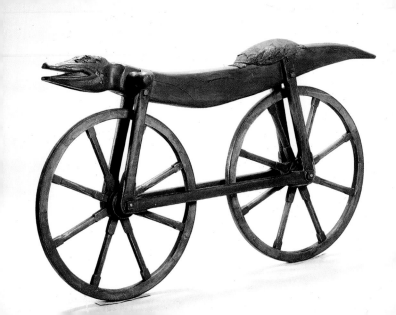

\mathcal{D}raisine

\mathcal{B}uilt in Germany around 1820 under a
license from its inventor, Baron von Drais. The wal-
nut frame carries a steering mechanism and a "belly
brace" to make pushing with one's feet easier.

Draisina
Costruita nel 1820 circa in Germania su licenza
dell'inventore, il barone von Drais, è in legno di
noce, ha lo sterzo e l'appoggia-pancia" per consentire
una più efficace spinta con i piedi.

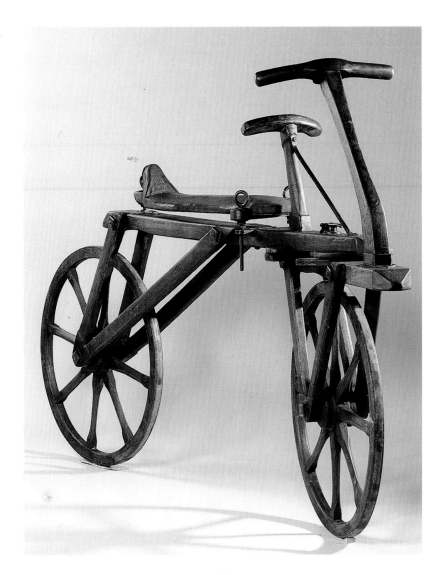

Michaudine

A French model built in 1867 in the work-shops of Ernest Michaux. The frame is solid iron, and the front wheel offers early examples of cranks and pedals. The rear wheel's iron brake pad is activated by turning the handlebar grip.
Detail: Saddle and brake lever.

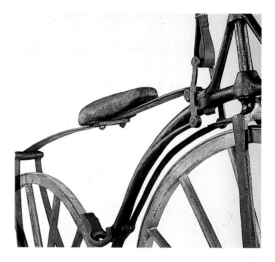

Michaudina
Modello francese costruito nel 1867 nelle officine di Ernesto Michaux. Ha il telaio in ferro massiccio. Sulla ruota anteriore ci sono le prime pedivelle con pedali. Sulla ruota posteriore una paletta di ferro, azionata da una cordicella che si tira ruotando le manopole del manubrio, funziona da freno.
Nel particolare: la sella e la leva del freno.

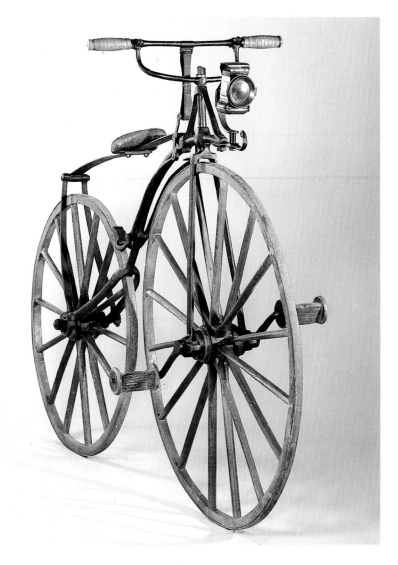

English Michaudine

*M*odel built after 1870, probably by the Coventry Sewing Machine Co. The frame is solid iron, and the wheels are wood with solid rubber rims. Detail: Rear wheel with brake pad.

Michaudina inglese

Modello costruito dopo il 1870, probabilmente dalla società inglese Sewing e C, ha il telaio in ferro massiccio e le ruote di legno con anelli di gomma piena. Nel particolare: la ruota posteriore con la paletta del freno.

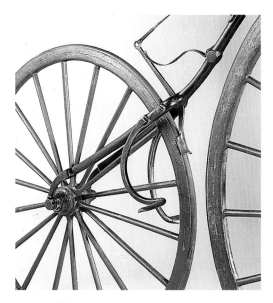

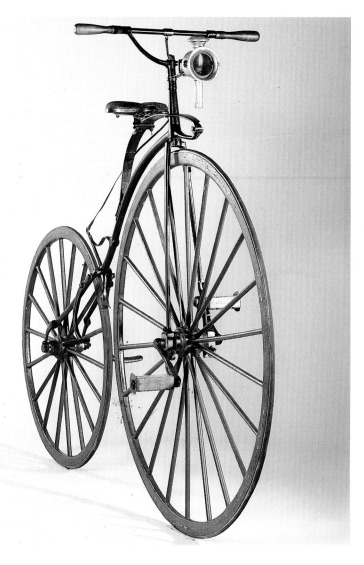

Touring Bike

*B*uilt in the workshops of Turri and Porro in 1875. The wheels, with convergent spokes, are 50 and 24 inches in diameter. The saddle, suspended on a large leaf spring, gives the rider the benefit of a considerable elasticity.
Detail: The oil headlamp.

Biciclo da turismo
Costruito nel 1875 nelle officine Turri e Porro. Le ruote, con raggi convergenti al mozzo, hanno il seguente diametro: 125 centimetri quella anteriore, 60 centimetri quella posteriore. Il sellino, applicato su una grande balestra, garantisce una notevole elasticità al mezzo.
Nel particolare: il fanale a olio.

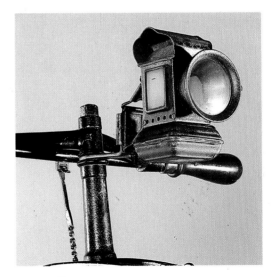

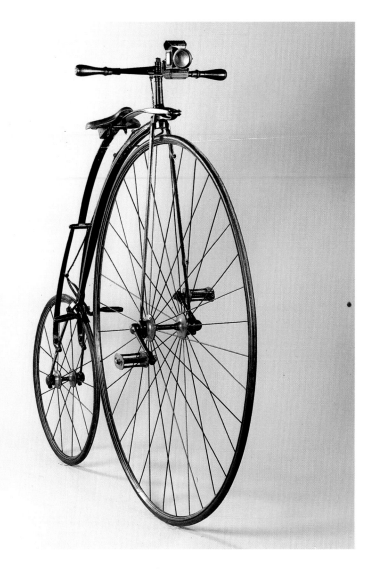

English Pennyfarthing

\mathcal{B}uilt in 1878 by D. Rudge's Withworth. The frame is made of iron tubing and the wheels—53 and 17 inches in diameter—have solid rubber rims and convergent spokes. The lever-operated brake acts on the front wheel.

Biciclo inglese

Costruito nel 1878 dal meccanico D. Rudge's Withworth, ha le ruote alte 133 e 43 centimetri. Il telaio è in ferro tubolare, le ruote sono ricoperte di gomma piena, con i raggi convergenti al mozzo. Il freno a leva è applicato sulla ruota anteriore.

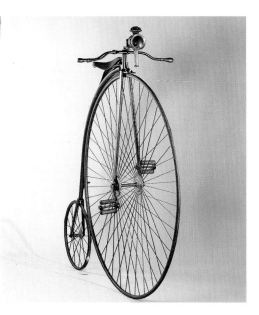

Meyer Bicycle

\mathcal{B}uilt in 1873 by Ernest Meyer, a German mechanic whose workshop was in Paris. The wheels, 53⅓ and 17 inches in diameter, have convergent spokes and a brake pad that acts on the front wheel.

Biciclo Meyer

Realizzato nel 1873 da Ernest Meyer, un meccanico tedesco con officina a Parigi, ha le ruote alte 134 e 43 centimetri. I raggi sono convergenti al mozzo, la paletta del freno è sulla ruota anteriore.

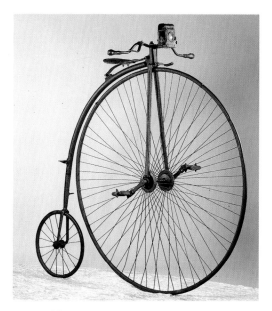

Military Bicycle

\mathcal{B}uilt for the Italian Carabinieri by the
Turri and Porro workshops. The wheels are 47½ and
21 inches in diameter. It has no headlamp. Both forks
are made of embossed sheet metal.

Biciclo militare

*In dotazione all'Arma dei carabinieri, è costruito
nelle officine Turri e Porro. Altezza delle ruote: 119 e
52 centimetri. È privo di fanale di illuminazione.
Entrambe le forcelle sono prodotte con lamiere
sbalzate.*

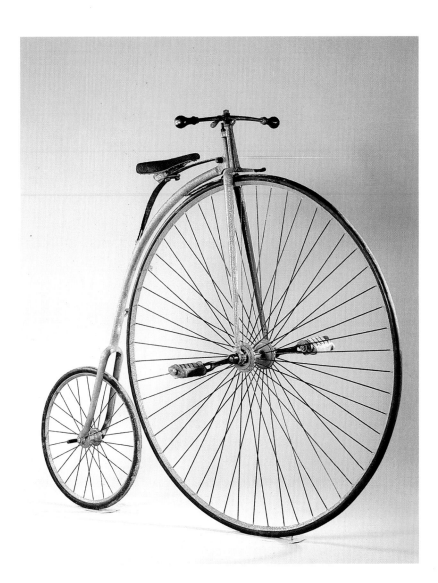

Racing Pennyfarthing

*E*nglish model built in 1890 by the Pilot workshop. The front wheel is 56 inches in diameter; the rear, 17 inches. Each turn of the cranks moves the bicycle ahead about five yards. As with all the best bicycles, the cranks were specially milled to allow the pedal position to be adjusted.
Detail: The candle headlamp.

Biciclo da corsa

Modello inglese realizzato nel 1890 nelle officine Pilot. Ha la ruota anteriore alta 140 centimetri, quella posteriore 43 centimetri. Sviluppa un rapporto di 4,39 metri ogni pedalata. Come tutti i migliori bicicli ha una speciale fresatura nelle pedivelle che permette di regolare la posizione del pedale.
Nel particolare: il fanale a candela.

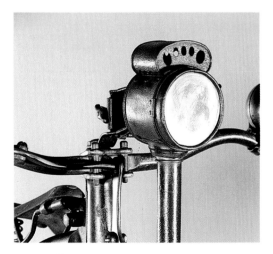

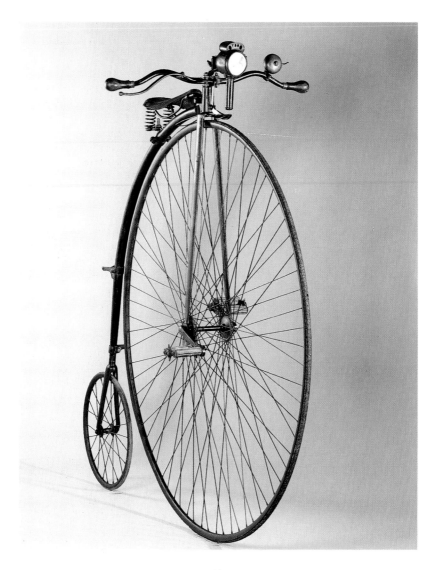

Monocycle

In 1869 the craftsman Rousseau of Marseilles built this monocycle, which perches the cyclist on the inside of a 2⅕ yards-high wheel. As there is no steering mechanism, it makes uncommon demands on the rider's sense of balance.

Monociclo

L'artigiano marsigliese Rousseau costruisce nel 1869 questo monociclo alto due metri, sistemando il velocipedista all'interno della ruota stessa. Sono però necessarie particolari doti di equilibrio per farlo muovere. È privo di sterzo.

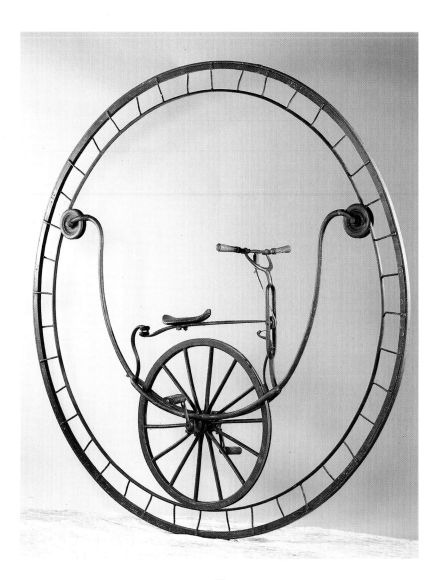

Bicycle

*I*n the years 1880-1885, England's Coventry Machinists' Co. introduced the Swift Dwarf Safety Roadstar, welcomed immediately by enthusiasts. The new Safety was fast and easy to handle. The front fork has a spring mechanism that acts as a shock absorber and two footrests for use going downhill.

Detail: A) The two footrests on the front wheel.

B) The special chain tensioning system.

Bicicletto

Nella prima metà degli anni '80 la società inglese Coventry Machinists' Company presenta, con un immediato interesse tra gli appassionati, il modello Swift Dwarf Safety Roadstar. Si tratta di una bicicletta da strada, veloce e maneggevole. La forcella anteriore ha un congegno a molla che funziona da ammortizzatore e due predellini per appoggiare i piedi durante la discesa.

Nel particolare: A) i due predellini sulla ruota anteriore per appoggiare i piedi durante la discesa.

B) il particolare sistema "tendicatena".

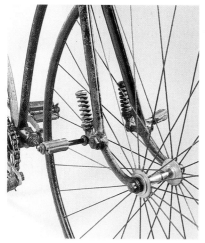 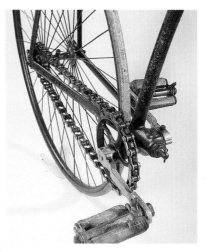

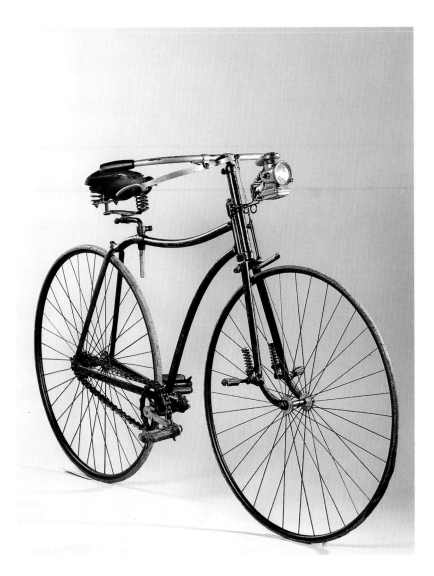

Racing Tricycle

\mathcal{A} Cripper model, built in Great Britain in 1885 and used primarily in competition. It has a gearbox with a differential gear on the left. The two rear drive wheels are 41 inches in diameter, while the front wheel, used for steering, is 20 inches in diameter. A lever brake acts on the front tire.

Triciclo da corsa
Modello Cripper, costruito in Gran Bretagna nel 1885, è utilizzato soprattutto nelle competizioni sportive. Ha la scatola con il differenziale sul lato sinistro. Le due ruote motrici sono alte 102 centimetri, quella alla guida 58 centimetri. Il freno è a leva con pressello sulla gomma anteriore.

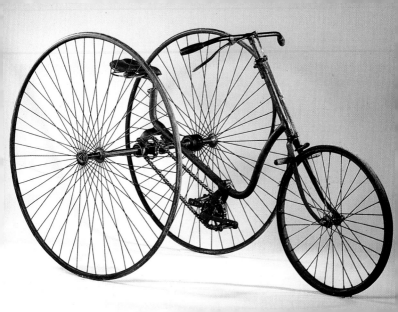

Racing Bike

The Excelsior model, built by Bayliss, Thomas & Co. of London in 1889. It has a tubular cross frame with a reinforcing crossbrace. The rider can adjust the pedals in different slits on the crank to obtain the best leverage for each terrain.
Detail: The cross-frame.

Bicicletto da corsa
Modello Excelsior costruito nel 1889 dalla Bayliss, Thomas & Co. di Londra, ha il telaio tubolare a forma di croce con traversino di rinforzo. A seconda del percorso il velocipedista può regolare il pedale nelle apposite fessure della pedivella calcolando il miglior punto leva.
Nel particolare: il telaio a croce.

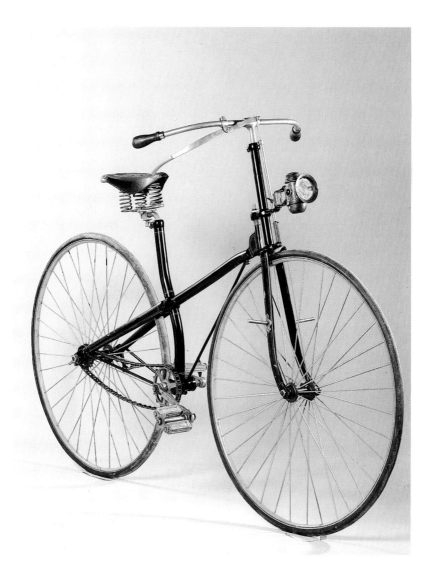

Raleigh Tricycle

\mathcal{B}uilt in Great Britain, the Invincible model has three wheels of almost identical diameters: 30½ inches for the rear wheels, and 28½ inches for the front wheel, which is used to steer. The gearbox is centrally mounted and has a fixed trip mechanism. The tricycle was used primarily by ladies of high society—their ample skirts prevented them from using the bicycle.

Detail: The chain and differential gear.

Triciclo Raleigh

Costruito in Gran Bretagna, il modello Invincibile ha le ruote sostanzialmente uguali: le due posteriori sono alte 76 centimetri, cinque in più di quella alla guida. La scatola del differenziale è centrale con scatto fisso. Il triciclo è utilizzato soprattutto dalle nobildonne, visto che l'ampiezza delle gonne impedisce l'uso dei bicicletti.

Nel particolare: la catena con il differenziale.

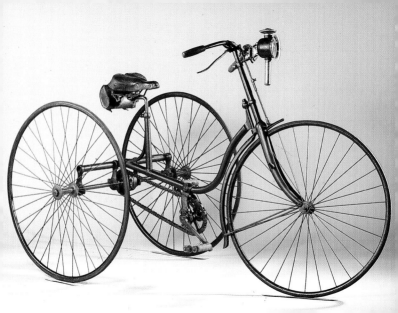

Clement Bicycle

\mathcal{B}uilt in 1890 by the French company Clement, this model displays a forerunner of the "diamond" frame used in the modern bicycle. The front wheel is 30½ inches in diameter, slightly larger than the rear wheel (28 inches), which has a fixed sprocket.

Detail: The long brake lever.

Bicicletto Clement
Realizzato nel 1890 dalla società francese Clement, ha il telaio "a quadro", antenato della moderna bicicletta. Ha la ruota anteriore di 76 centimetri, leggermente più alta di quella posteriore (70 centimetri), munita di pignone fisso.
Nel particolare: la lunga leva del freno.

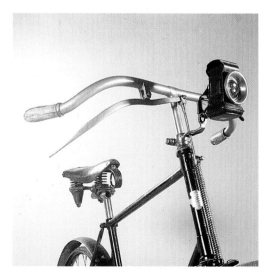

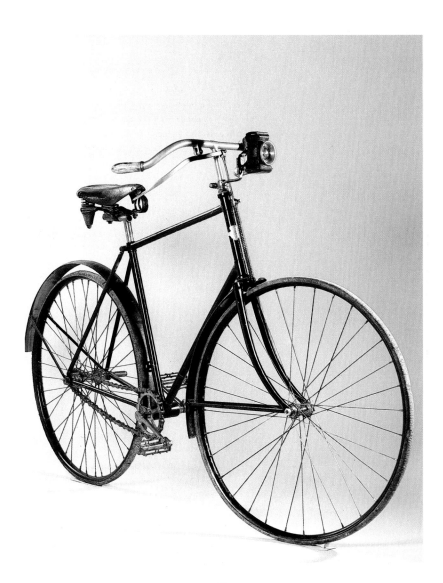

Bicycle

*T*his New Humeatic model from Ireland, made in 1890, sports a pair of the revolutionary new pneumatic tires, whose inner tubes are inflated with compressed air. The tires were patented by the Scottish veterinarian John Dunlop.

Bicicletta
Su questo modello irlandese New Humeatic nel 1890 vengono applicate le rivoluzionarie gomme pneumatiche, con tubolare gonfiato ad aria compressa, brevettate dal veterinario scozzese John Dunlop.

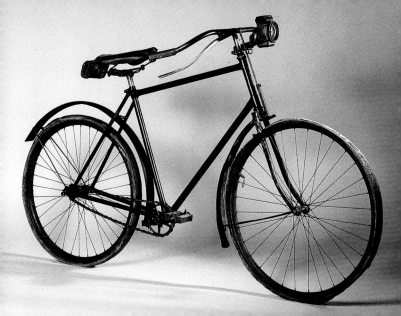

Bicycle with Cardan Shaft

\mathcal{B}uilt in 1899 in the F.N. workshop, this model has a unique innovation: a cardan shaft in place of the chain. The bike was not a success, however, because the shaft's gears were too fragile. The brakes were applied by backpedaling.

Detail: A) The cardan shaft which replaces the chain.
B) The acetylene headlamp.

Bicicletta a cardano

Realizzato nel 1899 nelle officine della F.N., questo modello ha una particolare innovazione: l'albero cardanico che sostituisce la catena. La bicicletta però non ha successo perché gli ingranaggi del cardano sono troppo fragili. Per frenare occorre contropedalare.

Nel particolare: A) il cardano che sostituisce la catena.
B) l'illuminazione ad acetilene.

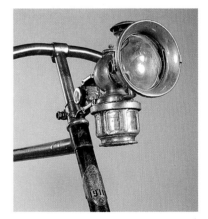

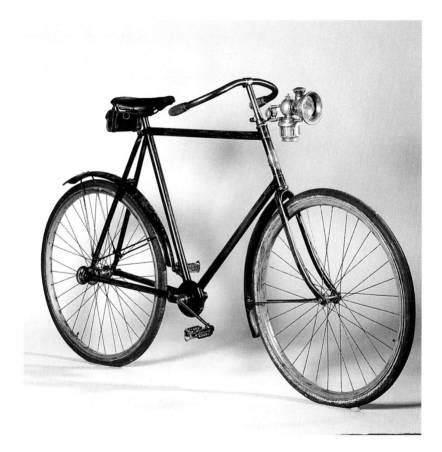

Bicycle

A hand-crafted model built in 1900 at the workshop of Ciclo Veronese in Milan. It has a frame outfitted with leaf springs, spring shock absorbers on the front wheel, and solid rubber tires with weight-reducing cutouts on the sidewalls.
Detail: The special shock absorbers on the front wheel.

Bicicletta
Modello artigianale realizzato nel 1900 nelle Officine Ciclo Veronese di Milano. Ha una struttura portante molleggiata con balestre, ammortizzatori a molle sulla ruota anteriore e gomme piene alleggerite ai lati.
Nel particolare: gli speciali ammortizzatori sulla ruota anteriore.

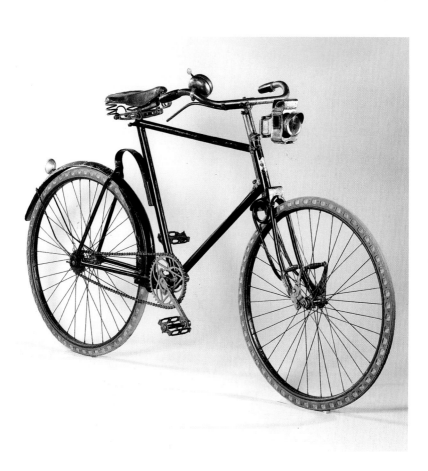

Touring Bike

*M*odel built in 1901 by the craftsman Edoardo Bianchi. It has a very tall frame, no mud guards, a rim brake on the front wheel, and a variable-speed gear and fixed sprocket on the rear wheel. The wheels are 28 x 1 3/8 inches in diameter. Detail: The flip-up saddle.

Bicicletta da turismo

Modello costruito nel 1901 dall'artigiano Edoardo Bianchi. Ha il telaio molto alto, senza parafanghi, il freno a pressello sulla ruota anteriore, la moltiplica e il pignone fisso sulla ruota posteriore. Le ruote sono da pollici 28 x 1$^3/_8$.

Nel particolare: la sella ribaltabile.

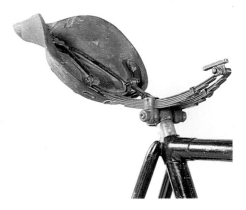

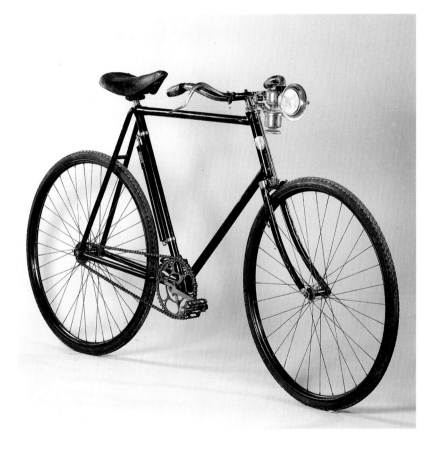

French Military Bicycle

\mathcal{T}he Capitaine Gérard model, built in 1904 for the French Army. A special hinged joint allows it to be folded in two and carried over the shoulder. Detail: The hinged joint.

Bicicletta militare francese

Il modello tipo Capitain Gerard, costruito nel 1904, è destinato all'Esercito francese. Uno speciale snodo permette di piegarla facilitando il trasporto a spalla. Nel particolare: lo snodo per piegarla.

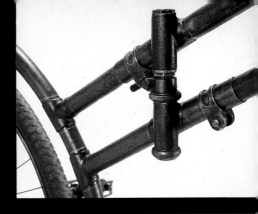

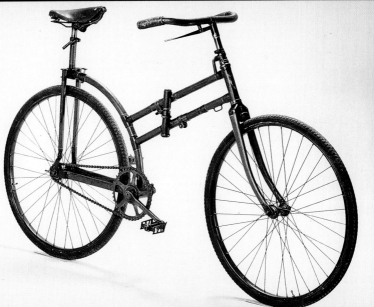

Boy's Bicycle

\mathcal{A} German model built by Fauber in 1912. The cranks and hub of the bottom bracket are forged as a single piece. Special ball bearings make it run smoothly.

Bicicletta per giovanetto
Modello tedesco costruito dalla Fauber nel 1912, ha le pedivelle e il mozzo centrale forgiate in un unico pezzo. Speciali cuscinetti a sfera favoriscono un'ottima scorrevolezza.

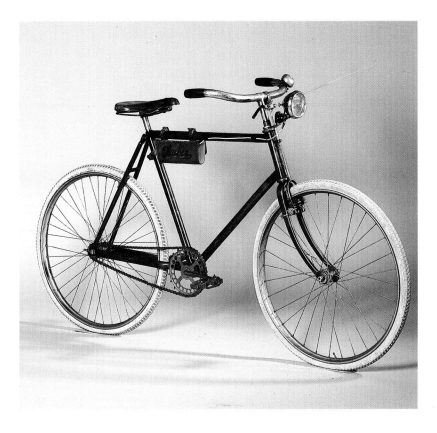

Fireman's Bicycle

\mathcal{B}uilt in 1905 at the workshops of Birmingham Small Arms in Great Britain, this model was designed for firemen on duty in petrochemical plants. It has a hose coiled inside the frame, a nozzle, and a pulley block.

Detail: A) The siren, activated by clicking the brake lever into its first position.

B) The fireman's helmet.

Bicicletta dei vigili del fuoco

Costruito in Gran Bretagna nelle officine della Birmingham Small Arms nel 1905, questo modello è destinato ai vigili del fuoco che operano all'interno delle industrie petrolchimiche. È dotata di una manichetta arrotolata all'interno del telaio, un becco a lancia, un paranco.

Nel particolare: A) la sirena, che è azionata dal primo scatto della leva del freno.

B) il casco dei vigili del fuoco.

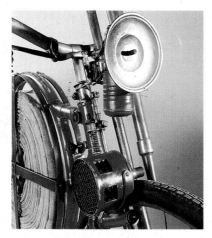 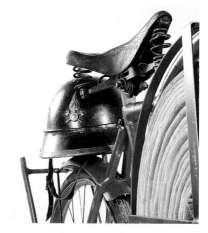

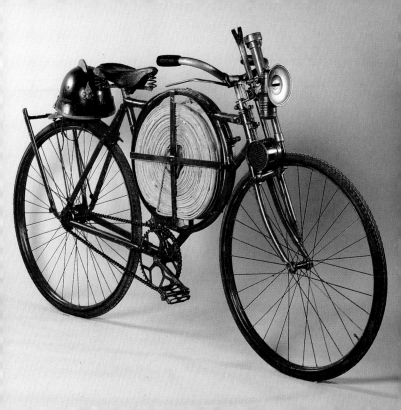

Light Infantry Bicycle with Rifle

\mathcal{T}his 1912 model has two spring shock absorbers on the front fork, a system with a hinged joint near the bottom bracket that allows the frame to fold in two, and a spring shock absorber pivot-mounted coaxially with the pedals. The headlight is an oil-lamp. The locking bolts for the hinged joint pull out from the top. This bicycle carried the Model 91 TS rifle.

Detail: The articulated joint on the central hub.

Bicicletta da bersagliere con fucile

Modello realizzato nel 1912, ha due ammortizzatori a molle sulla forcella anteriore; un sistema a snodo al mozzo centrale permette l'oscillazione e un molleggio su un perno coassiale all'asse dei pedali. L'illuminazione è con fanale a petrolio. I chiavistelli di chiusura dello snodo hanno la testa verso l'alto. Portava il fucile Modello '91 TS.

Nel particolare: lo snodo al mozzo centrale.

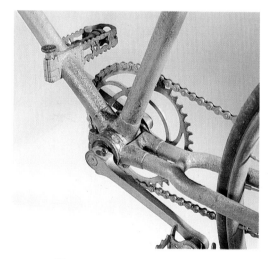

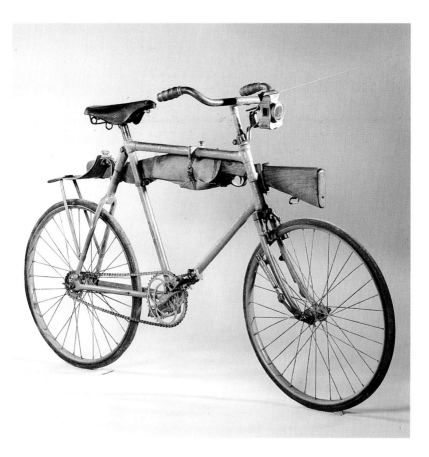

Light Infantry Bicycle with Machine Gun Carrier

This model built by Bianchi in 1914 was equipped to carry the Fiat 14/35 machine gun. A clamp on the top tube and a hinged ring under the saddle served to fasten the weapon in place. The wheels have reinforced tangential spokes and an additional Bowden-type brake. Detail: The 3⅕-inch hinged collar that holds the machine-gun barrel.

Bicicletta da bersagliere portamitragliatrice
Modello costruito dalla Bianchi nel 1914, è attrezzata per il trasporto della mitragliatrice Fiat 14/35. Un morsetto sul tubo orizzontale e un anello a snodo sotto la sella servono per fissare l'arma. Ha un freno supplementare modello Bowden e le ruote con raggi tangenti rinforzati. Nel particolare: l'anello di 80 millimetri con cerniera che ospita la canna della mitragliatrice.

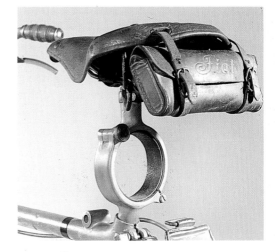

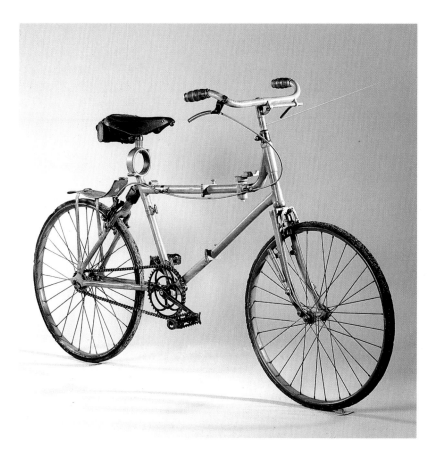

Light Infantry Bicycle with Machine-Gun Carrier

The Model 14, similar to the preceding example, is outfitted to carry the tripod and three-gallon water tank needed to cool the gun. The rear wheel is fitted with two fixed gears.

Detail: The clamp, which opens so the tripod can be hooked in.

Bicicletta da bersagliere portamitragliatrice
Modello 14, analogo al precedente, attrezzato per il trasporto del treppiede e del serbatoio da 12 litri d'acqua necessario al raffreddamento dell'arma. La ruota posteriore ha due ingranaggi fissi.
Nel particolare: il morsetto apribile per l'aggancio del treppiede.

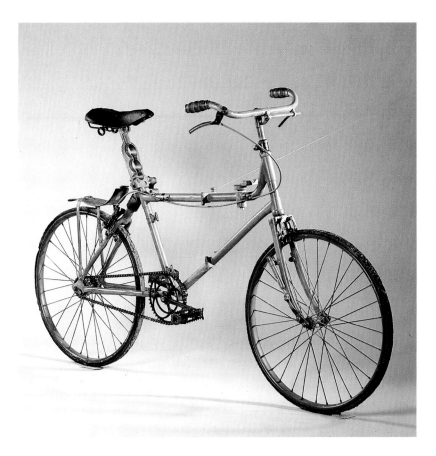

Bicycle for Light Infantry Officers

Model 25, loaded with accessories: a saber holder, carbide lamp, bell, free wheel sprocket, horn handlebar grips, tool bag, and Bowden-type rear brake.

Bicicletta da bersagliere per ufficiali
Modello 25 superaccessoriato: ha il porta-sciabola, il fanale a carburo, il campanello, il pignone a ruota libera, le manopole in corno, la borsetta porta-attrezzi, il freno posteriore modello Bowden.

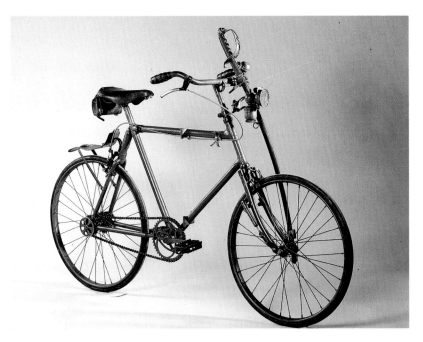

Non-Folding Military Bicycle

Standard model for all military units, including the Carabinieri. Carrying mud guards and a single fixed sprocket, it was used primarily for transportation around the military base. It has a unique sprung saddle.

Bicicletta militare non pieghevole
Modello in dotazione a tutti i reparti militari, compresi i Carabinieri. Ha i parafanghi, un solo pignone fisso, ed era prevalentemente utilizzata per gli spostamenti all'interno delle caserme. Ha una particolare sella molleggiata.

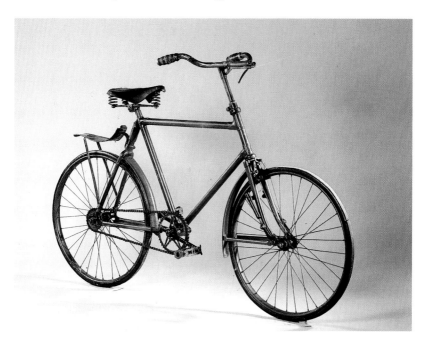

Light Infantry Bicycle (standardized)

The Model 25/34 is fitted with mud guards, rifle holder, and two sprockets on the rear wheel (18 and 23 teeth). The wheels are interchangeable, with a special lever locking mechanism. Like most other models of its type, this one also folds up for over-the-shoulder carriage.

Bicicletta da bersagliere (unificata)

Il modello 25/34 è munito di parafanghi, portafucile, due pignoni sulla ruota posteriore con 18 e 23 denti. Le ruote sono intercambiabili, con speciale bloccaggio a leva. Come tutti i modelli precedenti, anche questo è pieghevole per poter essere portato in spalla.

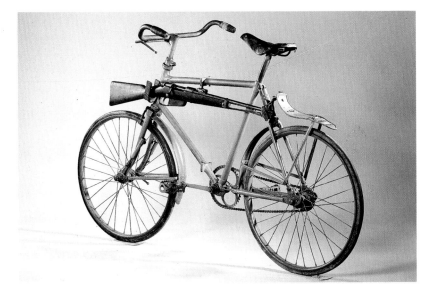

Light Infantry Bicycle

A model designed in 1930 by the Automotive Workshop of the Royal Army with a goal of maximizing the number of interchangeable parts. It is fitted with a cylindrical spring suspension and special gearing with two fixed sprockets (18 and 22 teeth). It has nesting cranks and automatic capillary lubrication.

Bicicletta da bersagliere

Modello progettato nel 1930 dalla Officina Automobilistica del Regio Esercito con l'obiettivo di avere il maggior numero possibile di parti intercambiabili. Ha le sospensioni su molle cilindriche e uno speciale cambio di rapporto dei due pignoni fissi da 18 e 22 denti. Ha le pedivelle a incastro e la lubrificazione automatica per capillarità.

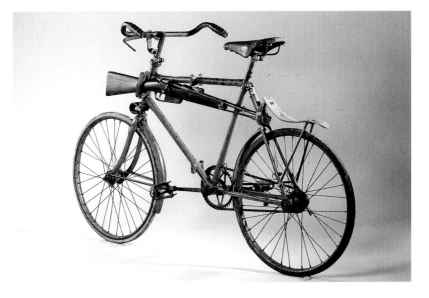

Cyclogenerator

\mathcal{A} model built in England in the 1930s.
Little more than a folding stand with a pedal-
driven dynamo, it served as a generator to charge
batteries for telephone communications and tent
lighting in the field. It saw extensive service in
World War II.
Detail: The cyclogenerator, folded-up.

Ciclogeneratore

*Modello di fabbricazione inglese costruito negli
anni '30. È semplicemente un cavalletto ripiegabile
con una dinamo azionata a pedali. Serviva a pro-
durre l'energia elettrica necessaria ad alimentare le
batterie per le comunicazioni telefoniche e l'illumi-
nazione nelle tende da campo. È stata largamente
usata nella Seconda guerra mondiale.
Nel particolare: il ciclogeneratore chiuso.*

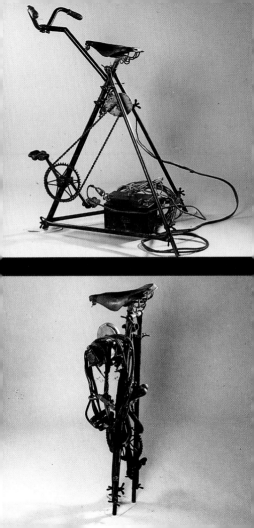

Unisex Touring Bike

The Saint Etienne Arms and Bicycle Factory in France built this model in 1920 using special techniques. The gear mechanism keeps the bicycle moving forward even when the rider pedals backwards.
Detail: The mesh clothes guard over the rear wheel.

Bicicletta unisex da viaggio
Prodotta nel 1920 con speciali tecniche dalla Fabbrica d'armi e cicli di Saint Etienne (Francia): un movimento di ingranaggi permette di procedere sempre avanti pur pedalando al rovescio.
Nel particolare: la retina para-veste sulla ruota posteriore.

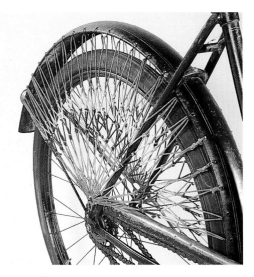

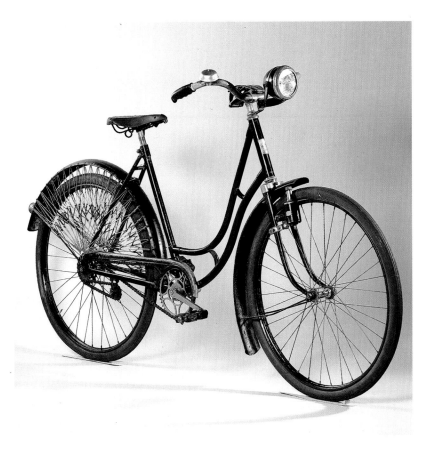

Flexible Bicycle

\mathcal{T}he Gran Turismo model built in 1924 by Officine Sintesi of Turin. Three leaf springs support the saddle for riding comfort. Of course, a system so full of springs has its dangers: in a collision it can turn the bike into a catapult.

Ciclo elastico
Modello Gran Turismo costruito nel 1924 dalle Officine Sintesi di Torino. Tre fogli di balestra sorreggono la sella, rendendo comodo e confortevole il viaggio. Questo sistema però, essendo troppo molleggiato, è pericoloso perché in caso di scontro rischia di trasformarsi in catapulta.

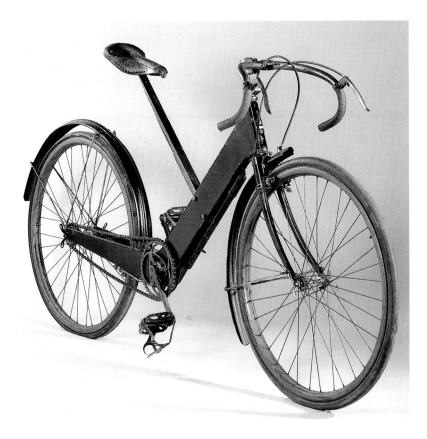

Gran Turismo Bicycle

\mathcal{L}ike many other car manufacturers, Opel built bicycles. This Opel model, made in Germany in 1928, is equipped with a carbide lighting system; the gas bottle is attached to the seat tube. The enormous Brooks saddle guarantees a comfortable ride.

Bicicletta Gran Turismo

Anche la Opel, come tante altre case automobilistiche, costruiva biciclette. Questo modello, realizzato in Germania nel 1928, è equipaggiato con un sistema di illuminazione a carburo, con il gasometro attaccato al canotto del tubo della sella. Una enorme sella Brooks garantisce un viaggio confortevole.

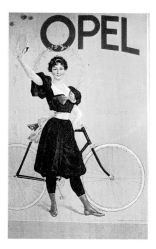

Detail: A contemporary advertising poster.
Nel particolare: locandina pubblicitaria d'epoca.

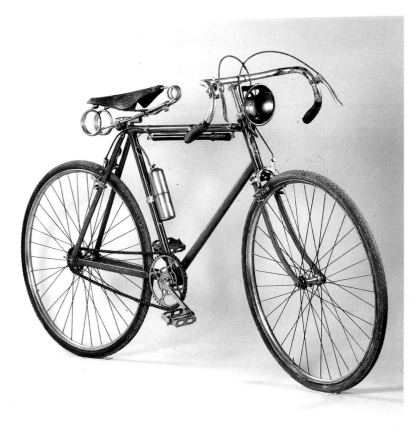

Racing Bicycle

\mathcal{T}he Three Rifles racing model built by
Great Britain's BSA in 1935. This is one of the first
bicycles to use the Vittoria Margherita three-speed
changer, patented by Officine Fratelli Nieddu of
Turin.
Detail: The Vittoria Margherita changer.

Bicicletta da corsa

*Modello corsa "Tre fucili" costruito nel 1935 in
Gran Bretagna nelle officine della Bsa. È una delle
prime biciclette a utilizzare il cambio di velocità a tre
rapporti "Vittoria Margherita", un brevetto italiano
delle Officine Fratelli Nieddu di Torino.
Nel particolare: il cambio "Vittoria Margherita".*

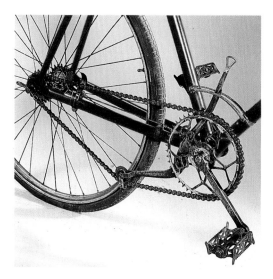

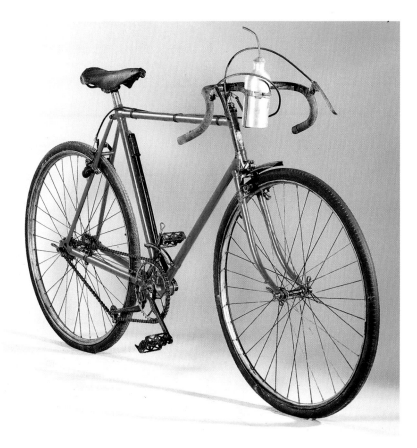

Ice Cream Cart

\mathcal{B}uilt by an anonymous craftsman around 1930 with unmistakable Art Nouveau lines. It was used by street vendors: two tubs inside held ice cream canisters immersed in ice. An Art Nouveau acetylene lamp on the sales counter was fueled from a gas bottle on the seat tube.

Details: A) The gilt eagle above the headlamp.

B) The reserve water tank.

Furgoncino dei sorbetti

Costruito da un artigiano nel 1930 circa, ricalca la linea Liberty. Serviva al sorbettaio ambulante: all'interno due mastelli contenevano le sorbettiere immerse nel ghiaccio. Sul piano di vendita un lampadario liberty alimentato ad acetilene con gasometro sul tubo della sella.

Nel particolare: A) l'aquila dorata sopra il fanale.

B) il serbatoio con la riserva dell'acqua.

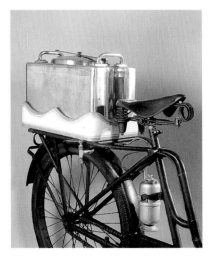

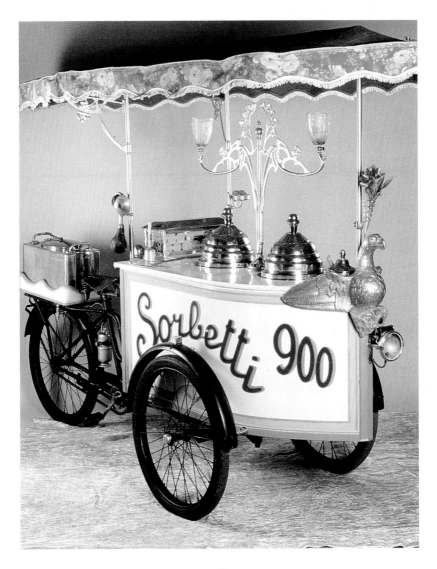

Men's Bicycle

A model built in 1936 by Pfeil Sudbracik in Germany. It has a very tall frame, a rim brake on the front wheel, and a coaster brake on the rear wheel.

Bicicletta da uomo
Modello costruito nel 1936 in Germania dalla Pfeil Sudbracik. Ha il telaio molto alto, il freno a pressello sulla ruota anteriore e il freno a "contropedale" sulla ruota posteriore.

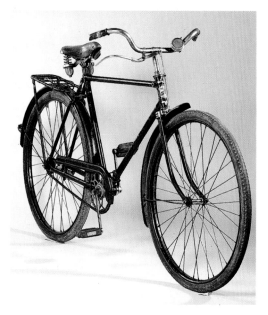

Sport Bicycle

*P*roduced in 1936 by the Maino company of Alessandria, Italy, this model has a coaster brake. Maino identified its bicycles with a special bronze nameplate attached to the head tube. The milled front fork is also an unmistakable trademark.

Bicicletta sportiva
Prodotto nel 1936 dalla ditta Maino di Alessandria, questo modello ha il freno "a contropedale". La Maino siglava le sue biciclette con una speciale targhetta di bronzo applicata sul tubo di sterzo. Inconfondibile la forcella con fresature.

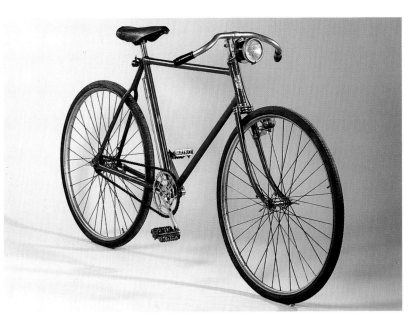

Tandem

This model was built by the craftsman Edoardo Fontana of Brugherio, near Milan. Bicycles for more than one person were usually hand-crafted; there were models for two, three, four, and even ten riders.

Dupletta (o Tandem)

Modello costruito dall'artigiano Edoardo Fontana di Brugherio (Milano). Le biciclette multiple venivano costruite prevalentemente da artigiani: esistono duplette, triplette, quadruplette e così via, fino alla decupletta.

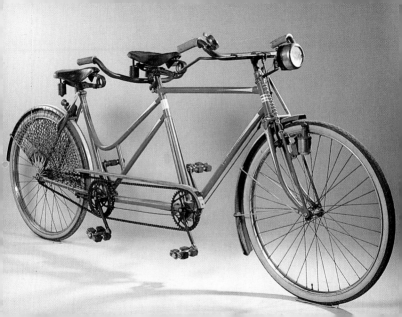

Deluxe Bicycle

\mathcal{B}uilt by BSA in 1938, this was one of the most accessory-laden models of the era, with a dynamo headlamp, rod-actuated brakes on both wheels, carrying handle, bell, pump, speedometer/odometer, and a regulator wheel for steering (one of BSA's trademark features). It cost 220 lire.

Detail: Dynamo headlamp.

Bicicletta di lusso
Costruito dalla Bsa nel 1938, era uno dei modelli più accessoriati dell'epoca: fanale a dinamo, freni a bacchetta su entrambe le ruote, maniglia per il trasporto, campanello, pompa, tachimetro con-tachilometri, volantino regolatore dello sterzo (tipico della Bsa). Costava 220 lire.

Nel particolare: il fanale a dinamo.

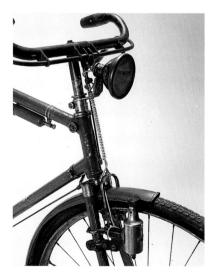

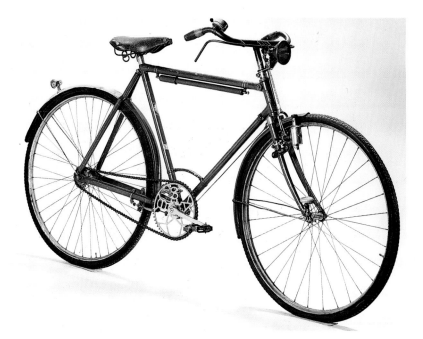

Men's Littorina

*N*amed after a diesel rail car of the Fascist era, this model was built by Officine Vianzone of Turin in 1939. It was also known as the "self-sufficiency bike," because it was made almost entirely of wood (iron had been rationed in anticipation of the war).

Detail: Wood handlebars and frame.

Littorina da uomo

Prodotta nelle Officine Vianzone di Torino nel 1939, era chiamata "bicicletta autarchica" perché costruita totalmente in legno (il ferro era assegnato in quantità limitata in previsione della guerra).

Nel particolare: il manubrio e il telaio in legno.

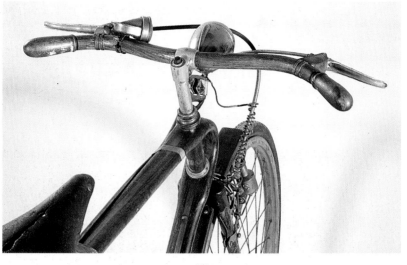

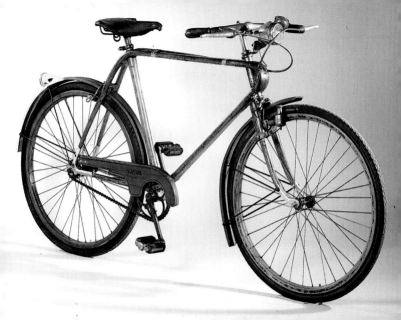

Women's Littorina

\mathcal{T}he women's version of the previous model. Here too, the frame, handlebars, and wheel rims are all of laminated wood.
Detail: The white rear mud guard, required by the wartime blackout laws, which prohibited the use of lights after dark.

Littorina da donna
Versione femminile del modello precedente. Anche in questo caso la struttura portante, il manubrio e i cerchioni delle ruote sono in legno multistrato.
Nel particolare: il parafango posteriore bianco, imposto nel corso della guerra dalla legge sull'oscuramento che vietava l'uso delle luci durante la notte.

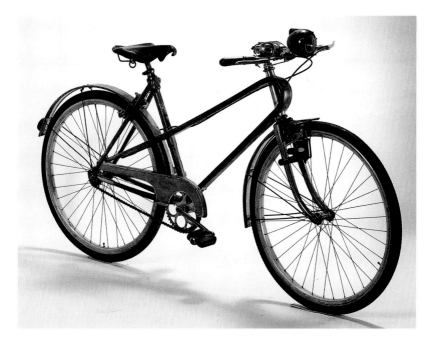

Night Watchman's Bicycle

\mathcal{B}uilt by Bianchi in 1940 and painted a military olive-drab. The frame is marked with a serial number of the Night Watch Corps, along with the municipal seal exempting it from the stamp tax. It has no headlamp because the watchmen had to make their rounds inconspicuously.

Bicicletta per i servizi di vigilanza notturna
Costruita nel 1940 dalla Bianchi, è di colore militarizzato. Sul telaio c'è il numero di matricola del Cvn, Corpo di vigilanza notturna, con il bollino comunale che esenta dalla tassa da bollo. La bicicletta è priva di fanale perché il vigile doveva circolare senza farsi notare.

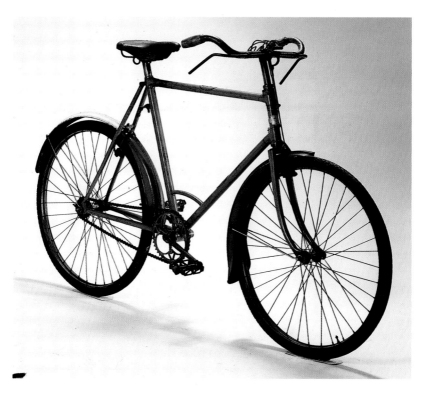

Ice Cream Cart

\mathcal{T}his three-wheeler, built by the Doninzetti company of Milan in 1940, was used by street vendors. Inside are two cork tubs to hold ice cream canisters immersed in ice.

Furgoncino dei gelati

Triciclo costruito dalla ditta Doninzetti di Milano nel 1940. Era utilizzato per la vendita ambulante dei gelati. All'interno ci sono due mastelli di sughero con le gelatiere immerse nel ghiaccio.

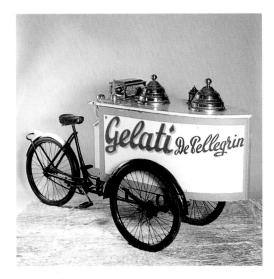

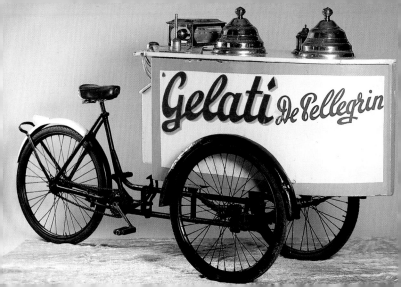

Traveling Bicycle

\mathcal{A} model for leisurely riding, built by the Dutch company Phillips, with a very tall frame, rod-actuated brakes with clip mountings, and front and rear lighting.

Detail: The cut-out Phillips trademark on the chain wheel.

Bicicletta da viaggio

Modello costruito dalla società olandese Phillips, ha una struttura portante molto alta, freni a bacchetta con attacchi a fascetta, un sistema di illuminazione anteriore e posteriore.

Nel particolare: il marchio Phillips ritagliato sull'ingranaggio centrale.

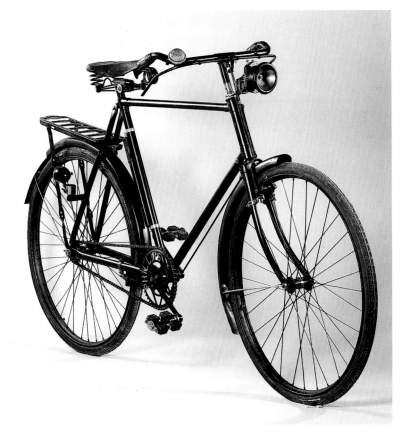

Traveling Bicycle

\mathcal{A} Wolsit Legnano model built between 1936 and 1940. It has dynamo lighting, a security lock and small light on the rear wheel, 26-inch wheels with wood rims, and white-sidewall Pirelli Stella tires.

Bicicletta da viaggio

Modello della Wolsit Legnano costruito nel periodo '36-'40, ha l'illuminazione a dinamo, il lucchetto di sicurezza con fanalino sulla ruota posteriore, ruote da 26 pollici con cerchioni in legno, gomma Pirelli Stella-striscia bianca.

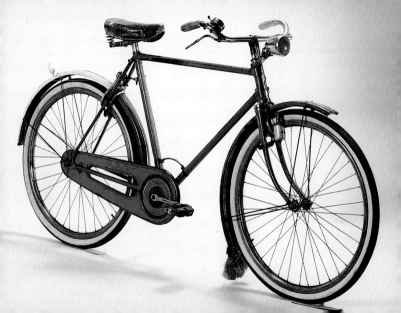

Traveling Bicycle

A model built by Umberto Dei of Milan in the late 1930s. It has rod-actuated brakes, sprung leather saddle, handlebar bag support, carrying handle (for when the bike had to be brought indoors), 28-inch wheels, and balloon tires. It was called the Balloon Dei.

Bicicletta da viaggio

Modello realizzato da Umberto Dei di Milano verso la fine degli anni '30. Ha i freni a bacchetta, sellone in cuoio con supporto di molle, portapacchi sul manubrio, maniglia per il trasporto a mano (serviva quando si doveva portarla in casa), ruote da 28 pollici con gomme maggiorate. Veniva chiamata la "Dei Palloncino".

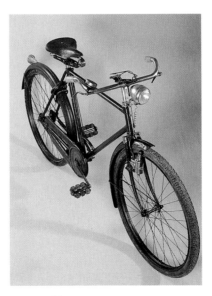

Bianchi Internal Brake Model

This is one of Bianchi's finest pre-WWII models. It has rod-actuated brakes housed inside the frame tubes, special chrome plating, 28-inch wheels and Pirelli tires. It was very difficult and expensive to repair because of the complicated brake system.

Bicicletta Bianchi Mod. "Freni Interni"

È uno dei migliori modelli realizzati dalla Bianchi prima della Seconda guerra mondiale. Ha i freni a bacchetta alloggiati all'interno dei tubi del telaio, speciali cromature, ruote da 28 pollici, pneumatici Pirelli. Era una bicicletta molto costosa e difficile da riparare, data la complessità del sistema frenante.

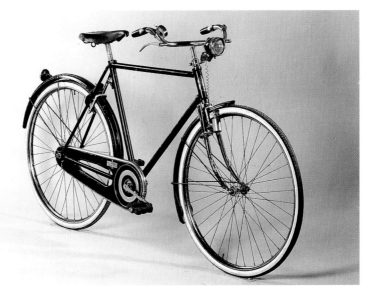

Unisex Bicycle

\mathcal{B}uilt by Regina of Milan in 1942, this men's model is convertible to a women's model: all that's required is to unscrew a support on the top tube and reattach it lower down on the seat tube.

Below: The women's version of the model, with the top tube reattached on the seat tube.

Bicicletta unisex

Costruito dalla Regina di Milano nel 1942, è un modello da uomo che si può trasformare in versione femminile: basta svitare un supporto del tubo centrale e incastrarlo nella canna obliqua.
Versione femminile del modello precedente, con il tubo incastrato sulla canna obliqua.

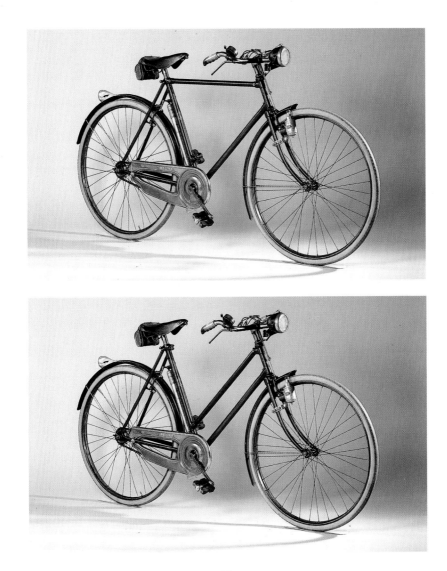

English Military Bicycle

\mathcal{T}he Thomson model built in Great Britain by Royal Enfield between 1943 and 1945. It has a very tall frame and a rifle holder on the right side. When carried, the rifle butt was braced against a rest on the steeply raked fork and the barrel was secured to the handlebars with a strap.

Detail: Rear wheel gears and step for mounting the bicycle.

Bicicletta militare inglese

Modello Thomson costruito in Gran Bretagna dalla Royal Enfield nel periodo '43-'45. Ha il telaio molto alto; il portafucile è sul lato destro, con supporto del calcio alla forcella obliqua e la canna fissata con cinghietta al manubrio.

Nel particolare: l'ingranaggio della ruota posteriore con il predellino per montare in sella.

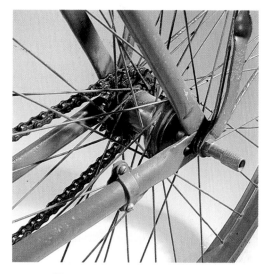

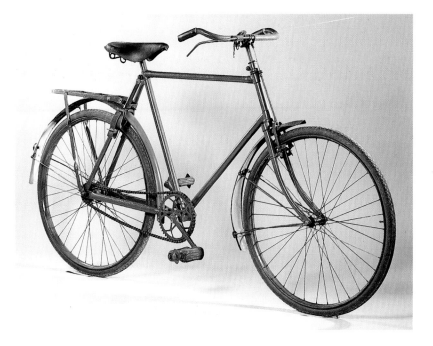

Cycle Taxi

*H*and-built by an anonymous craftsman, this model replaced taxicabs during the gasoline shortage of 1943. The cycle taxi was in great demand among hotels that wanted to ensure regular service for their guests.

Ciclotaxi

Di costruzione artigiana, questo modello nel 1943 sostituiva i taxi, costretti a restare fermi per la mancanza di benzina. Il ciclotaxi era acquistato in modo particolare dagli alberghi che volevano assicurare un regolare servizio ai clienti.

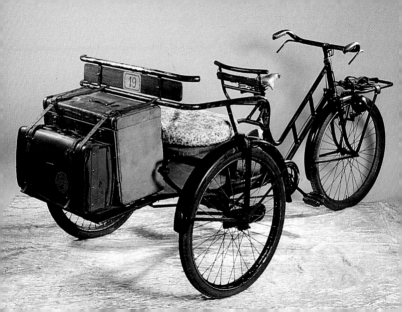

Sporting Bicycle

*B*uilt by Beltramo of Turin in 1945, this model has coaster brakes and a dynamo headlamp. A unique feature of the frame is the double seat tube. The chain guard was referred to as the "pistol guard" because of its shape.

Bicicletta sportiva

Prodotto dalla ditta Beltramo di Torino nel 1945, questo modello ha il freno "a contropedale" e il fanale a dinamo. Un particolare del telaio: il tubo inclinato è sdoppiato. Il carter copricatena era chiamato "carter a pistola".

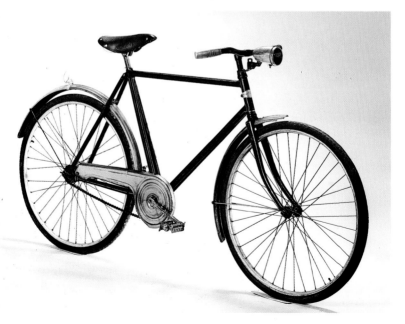

Pair of Bianchi Bicycles

\mathcal{M}odels built in 1946 with wood rims and dynamo headlamps. The lady's bike has a showy silk clothes guard and a tooled leather saddle.

Coppia di biciclette Bianchi
Modelli costruiti nel 1946, hanno i cerchioni in legno e l'illuminazione a dinamo. Sulla bicicletta da donna una sgargiante "paraveste" in seta e sella in cuoio con incisioni a rilievo.

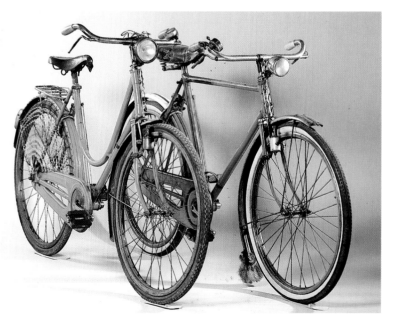

The Mosquito Moped

Built by Milan's Officine Garelli of Sesto San Giovanni (Milan) in 1946, this model has a two-stroke auxiliary engine with roller drive that could be attached to any kind of bicycle. It generates eight-tenths of a metric horsepower, equivalent to 38 cc, producing a maximum speed of 30 miles per hour. Detail: An advertising postcard.

Ciclomotore Mosquito

Costruito nelle Officine Garelli di Sesto San Giovanni (Milano) nel 1946, ha un motorino ausiliario a due tempi con trazione a rullo, applicabile a qualsiasi tipo di bicicletta. La potenza è di otto decimi di cavallo, pari a 38 cc, con una velocità massima di 50 chilometri l'ora.
Nel particolare: cartolina pubblicitaria dell'epoca.

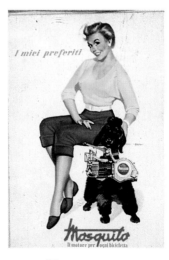

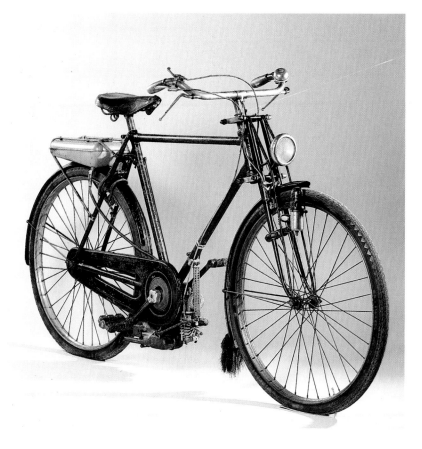

Cucciolo (Puppy) Moped

\mathcal{B}uilt by Ducati of Modena in 1946, this model has a 48-cc four-stroke engine, two gears, and a chain drive. The moped was advertised on 78 rpm records with the refrain "Come take a ride with me, I'll put you on a Puppy, the little motor bike that putt-putts like my heart."

Detail: The engine and chain drive.

Ciclomotore Cucciolo

Realizzato dalla Ducati di Modena nel 1946, ha un motore a quattro tempi, 48 cc, due marce e la trazione a catena. Veniva reclamizzato su dischi a 78 giri con il ritornello: "se vuoi venir con me, ti porterò sul Cucciolo, il motorino piccolo che batte come il mio cuor".

Nel particolare: il motore con trazione a catena.

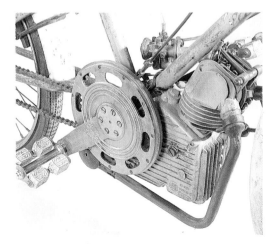

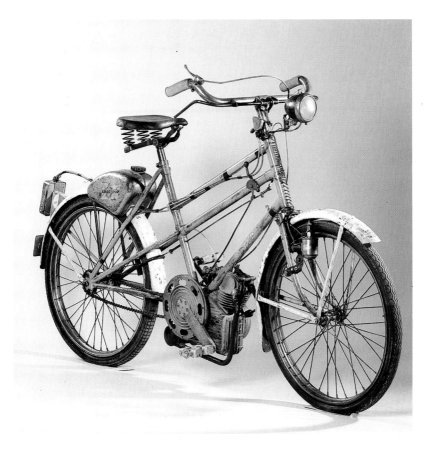

Chinese Bicycle

*T*he Flying Pigeon, built in China under a license from Legnano. It has a very tall frame and is yet another bike loaded with accessories. Inside the rear hub is a three-gear changer operated by a shift lever on the handlebars.

Bicicletta cinese

Modello Flying Pigeon costruito in Cina su licenza della Legnano. Ha il telaio molto alto, è superaccessoriata e all'interno del mozzo della ruota posteriore ha un cambio a tre velocità comandato da una levetta sul manubrio.

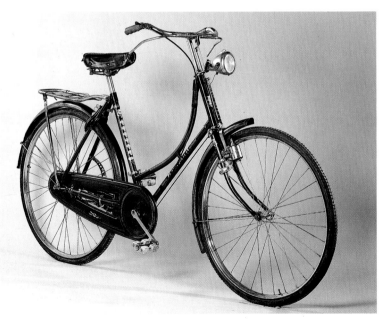

Delivery Bicycle

\mathcal{A} Bottecchia model built in Vittorio Veneto. It was used for home deliveries in the postwar period, particularly by craftsmen and shopkeepers. Note the reinforced frame and the two capacious racks.

Bicicletta da trasporto
Modello Bottecchia costruito a Vittorio Veneto. Era utilizzato nel Dopoguerra soprattutto da artigiani e bottegai per le consegne a domicilio. Da notare il telaio rinforzato e i due spaziosi portapacchi.

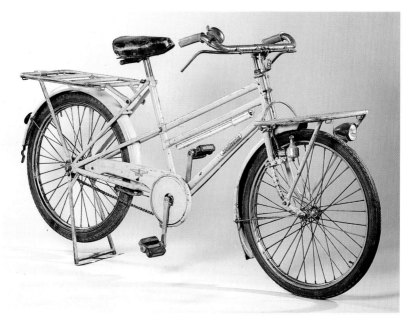

Racing Bicycle

\mathcal{I}n honor of Fausto Coppi's triumphant victory in the 1949 Tour de France, Bianchi built this Coppi-Tour de France model. It has a ten-speed Campagnolo gear group and a light alloy frame and wheels.
Detail: The Campagnolo shift levers.

Bicicletta da corsa

In onore della trionfale vittoria di Fausto Coppi al Tour de France del 1949, la Bianchi costruisce questo modello "Coppi-Tour de France". Ha il cambio Campagnolo a dieci velocità, telaio e ruote in leghe leggere.
Nel particolare: la leva del cambio Campagnolo.

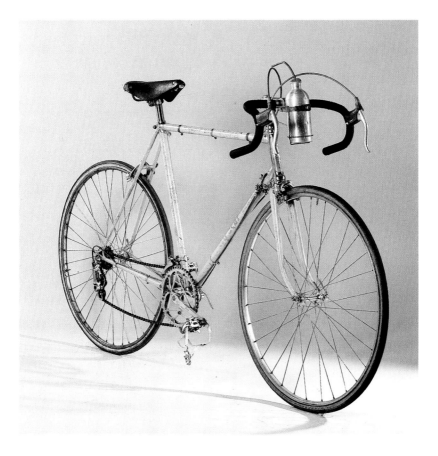

Snow Bike

\mathcal{B}uilt in the 1950s, this model's frame is mounted on two little skis. It is very lightweight, so it can be carried on the shoulder when walking up the slope.

Bici da neve

Modello costruito negli anni '50, ha la struttura portante montata su due piccoli sci. È molto leggero per poter essere portato in spalla durante la risalita.

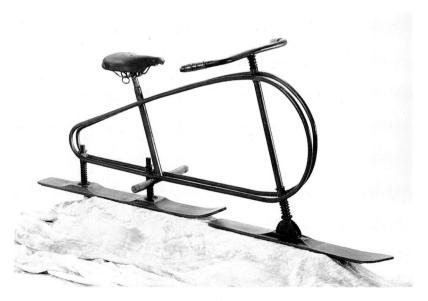

Children's Tricycles

In the second half of the 19th century, tricycles began winning popularity with children. The first models were very simple, with wood wheels rimmed in iron. Then, gradually, they followed the evolution of the bicycle. Below and on the next two pages are models from 1880 to 1950.

Tricicli per bambini

Nella seconda metà dell'800 i tricicli hanno iniziato a diffondersi tra i bambini: i primi modelli erano molto semplici, con ruote di legno cerchiate in ferro; poi, a mano a mano, hanno seguito l'evoluzione della bicicletta. Nelle foto: modelli costruiti tra il 1880 e il 1950. In questa pagina e nelle due seguenti.

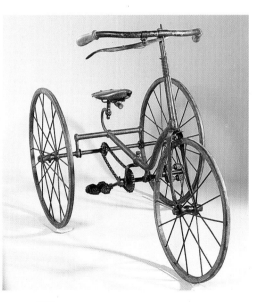

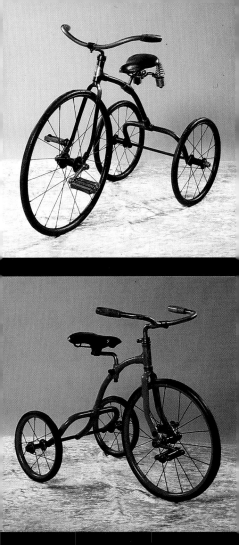

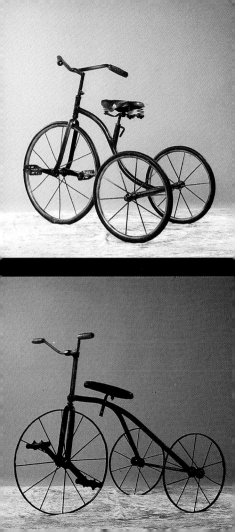

Folding Bicycle

A Model 2000 from 1960-65, when builders began trying out all sorts of ways to reduce bicycle dimensions.

Bicicletta pieghevole
Modello 2000 realizzato nella prima metà degli anni '60, quando i costruttori si sbizzarrivano per ridurre sempre di più le dimensioni.

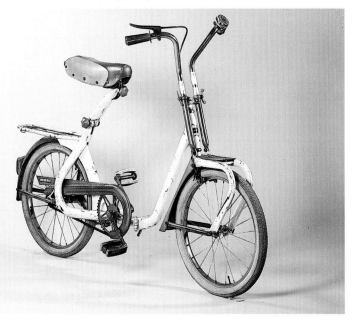

Baggable Bicycle

The Pocket Bicy model built by the T & C company of Carugate, near Milan. It folds up into a suitcase and offers cable brakes and wheels with a diameter of 12 inches.

Bicicletta in valigia

Modello "Pocket Bicy" realizzata dalla ditta T & C di Carugate (Milano). Il sistema frenante è a filo; le ruote hanno un diametro di 12 pollici. A riposo si può chiudere nella valigia.

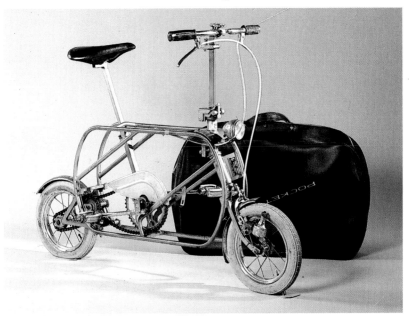

Ordinance

\mathcal{T}he ordinance of 1811 prohibited the use of "so-called velocipedes (bicycles)" in the streets of downtown Milan.

Ordinanza
L'ordinanza del 1811 che vieta l'uso dei "cosidetti velocipedi" nelle vie centrali di Milano.

N.° 7261

Direzione Generale Della Polizia

Avendo l'esperienza dimostrato che il correre dei cosidetti velocipedi può riuscire pericoloso ai passeggeri.

La direzione Generale suddetta.

ORDINA

I. È proibito girare nottetempo su velocipedi per le contrade e per le piazze interne della città.

II. È tollerato però il corso dei medesimi sui bastioni e sulle piazze lontano dall'abitato.

III. Coloro che contravverranno il suddetto Ordine saranno puniti con la confisca della macchina.

Milano, il 26 giugno 1811.

Il Capo Della Polizia.

Giovanni Tom. Roux.

Rim Puncher

\mathcal{A} special tool mounted on a stand, used for indexing and punching rims with a number of eyes (28, 32, 36, or 40) to match the desired number of spokes to be mounted.

Divisore
Speciale attrezzo montato su una colonna, serviva per la divisione e la perforazione dei cerchioni in un numero di fori (28-32-36-40) equivalenti al numero dei raggi che si volevano montare.

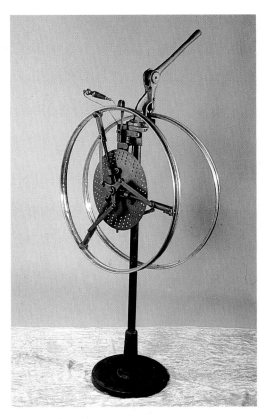

Headlamps

\mathcal{A} tree of lights displaying the entire evolution of bicycle illumination, from candle lamps (not to illuminate but to alert other travelers of one's approaching bike) to dynamo-powered models.

L'illuminazione

Su questo "albero" c'è tutta l'evoluzione dei sistemi di illuminazione, dai fanali a candela (non per vedere, ma per essere visti) a quelli a dinamo.

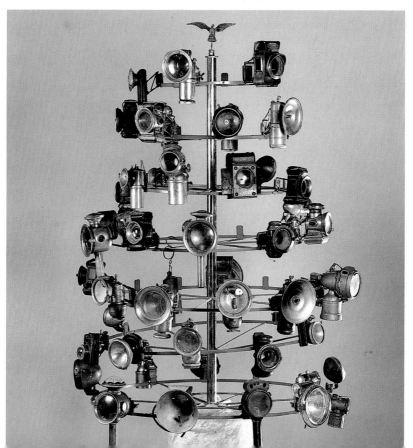

Licenses

\mathcal{A} collection of road licenses from various periods, certifying payment of the road taxes imposed on bikes.

Bolli

Serie di bolli di modelli di epoche diverse che confermavano l'avvenuto pagamento delle tasse di circolazione sui velocipedi .

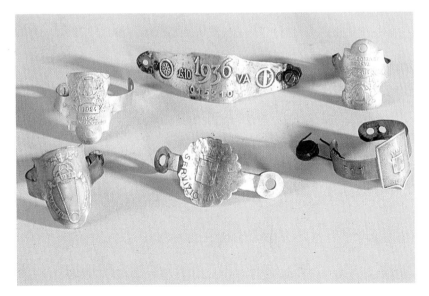

Metal Nameplates

Some of the many metal nameplates with which builders "signed" their bicycles.

Targhette metalliche
Alcune targhette metalliche con le quali i costruttori "siglavano" le loro biciclette.

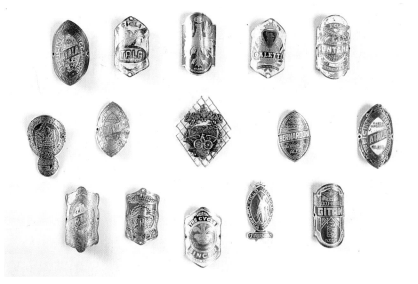

Mexico Bicycle

\mathscr{A} bicycle for major competitions, built by Ernesto Colnago of Cambiago, near Milan. Giuseppe Saronni won the 1983 Giro d'Italia with this bike equipped with a Campagnolo 12-speed gear group and a special-alloy frame. Colnago marks his bicycles with the ace of clubs.

Ciclo Mexico
Bicicletta per grandi competizioni sportive costruita da Ernesto Colnago di Cambiago (Milano). Con questo modello Giuseppe Saronni ha vinto nel 1983 il Giro d'Italia. Il cambio Campagnolo ha 12 velocità; la struttura portante è in leghe speciali. Colnago sigla le sue biciclette con l'asse di fiori.

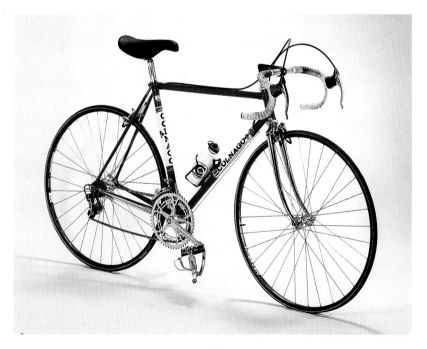

Mountain Bike

\mathcal{T}he Colnago Super De Luxe has 21-speed gearing. The frame is made from special steel and the wheels have knobby tires for easy climbing up mountain slopes.

Mountain Bike

Modello Super De Luxe costruito da Colnago, è munito di un cambio di marce con 21 rapporti di velocità. Il telaio è in acciaio speciale e le ruote sono gommate ad artiglio per superare con facilità le pendenze montane.

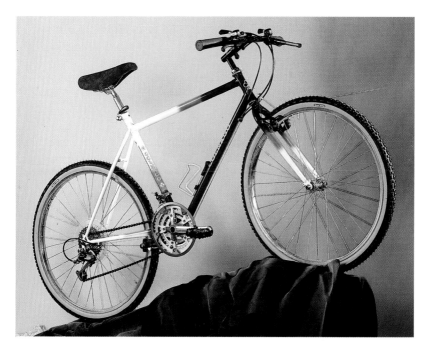

Master Krono Record

\mathcal{B}uilt by the Colnago workshop in 1986, this is a special model used by professional racers in time trials. It offers 24- and 26-inch carbon-fiber disk wheels, a molybdenum steel frame, and 12-speed gearing.
Detail: The disk wheel and drive mechanism.

Master Krono Record
Prodotto nelle officine Colnago nel 1986 è un modello speciale utilizzato dai corridori professionisti particolarmente nelle tappe a cronometro. Ruote lenticolari al carbonio da 24 e 26 pollici. Il telaio è in acciaio al mobildeno. Cambio a 12 velocità.
Nel particolare: la ruota lenticolare e il movimento di trasmissione.

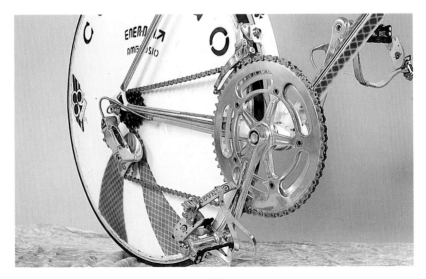

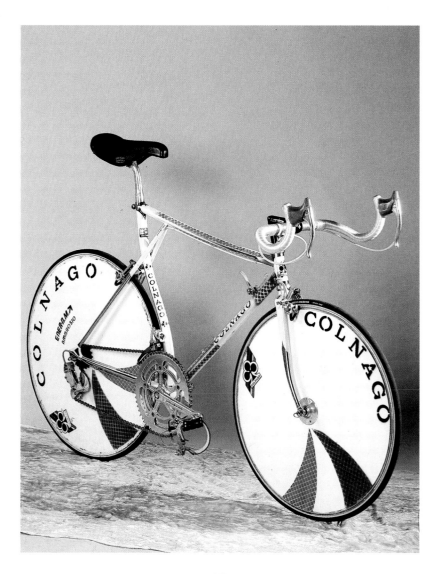

Colnago Ferrari

\mathcal{D}esigned by Ferrari Engineering and built by Colnago this model has a carbon-fiber frame and eight-speed gearing controlled by a single shift lever. It reconfirms Colnago's standing as one of the world's most advanced bicycle builders.

Details: A) The revolutionary shifting mechanism. The gears are housed in
an oil bath inside a light alloy gearbox.
B) The hydraulic front brake.

Colnago Ferrari

Modello progettato dalla Ferrari Engineering e costruito da Colnago. Ha una struttura in fibra di carbonio, cambio di velocità differenziato in otto rapporti comandati da un unica levetta. Con questo modello Colnago si conferma uno dei più avanzati costruttori a livello mondiale.

Nel particolare: A) il rivoluzionario cambio: gli ingranaggi sono a bagno d'olio nella scatola in lega leggera.
B): il freno idraulico.

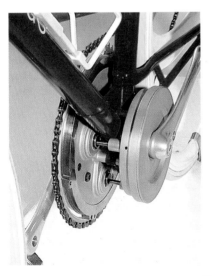

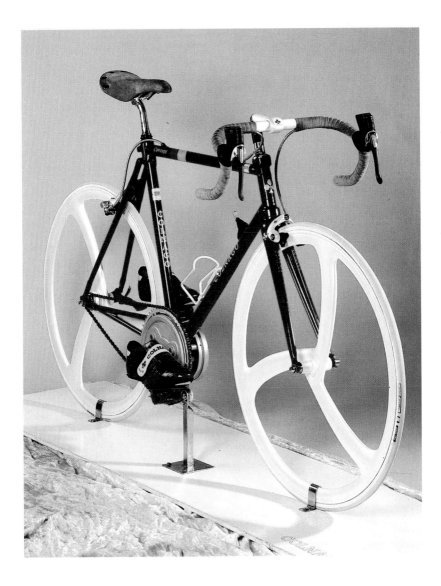

A Bit of History

*T*he history of the bicycle really began late one June afternoon in 1791, when the French Revolution was in full swing. The Count de Sivrac showed up in the gardens of the Palais Royal in Paris with a novelty: a wooden bar with a fork at either end, each holding a carriage wheel. This odd vehicle, immediately dubbed the *cheval de bois* (wooden horse), quickly caught on among the Parisians even if it was uncomfortable (especially on the streets of the day) and hard to propel.

Within a few years, many builders were copying the strange contraption (which Sivrac had declined to patent), embellishing it with decorative friezes and carvings. They also found a more dignified name for it: first *célérifère* (from the Latin meaning "I carry fast"); then—after the Revolution—*vélocifère*, and still later, *vélocipède* (which, as "velocipede," was the only form to become anglicized).

No one knows who brought the velocipede to Italy or how, but it certainly must have become popular very quickly, since by 1811 it

had forced Milan's General Director of Police to issue a ban: "It having been learned by experience that the rushing about of the aforesaid velocipedes may be dangerous to pedestrians," he prohibited "the nighttime riding of velocipedes through streets and squares within the city" threatening the machine's confiscation. Racing around ramparts or in squares far from the center of town was still tolerated.

<center>S T E E R I N G</center>

\mathcal{F}or about twenty years the *vélocifère* grew in popularity among aristocrats and the middle class, more as a curiosity than as a serious means of transportation. It was hard enough to push along; but still worse, it was impossible to steer because there was no steering mechanism.

To the profound disappointment of the French, the first fundamental innovation in the *vélocifère* was made in Bavaria by Karl Friedrich von Drais, Baron of Sauerbronn. Von Drais introduced a *vélocifère* with a front wheel attached to a vertical shaft, "which permits the velocipedestrian to turn left or right at his pleasure"; moreover, it was outfitted with a stomach rest, or belly brace, to make it easier to push along.

Enthusiasts were quick to appreciate the Draisine. After being patented in Baden on January 5, 1817, the number in use grew quickly, sparking an intense competitiveness among sporting types. The first

official bicycle race was held in Munich on April 20, 1819, from the center of town to Schloss Nymphenburg and back, a total of six miles. The event, with 26 Draisines participating, was won by Herr Semmler of Munich in a little over half an hour (31 minutes and 30 seconds).

Meanwhile, the Draisine had crossed the German borders and Drais (who was awarded a professorship in mechanical engineering for his invention) engaged the mechanic Louis Joseph Dineux to protect his interests by patenting the vehicle in France as well.

It mattered little that the local newspapers couldn't resist mocking Drais; the invention was such a success in Paris that in the Parc de Monceau, Dineux opened the first school to "teach how to ride the new medium of transportation."

After Paris, Drais introduced his Draisine in London, appointing the mechanic Denis Johnson as his agent. A year later, a large building opened in London—the first indoor school for what was then called the "hobby horse," where ladies might learn to mount the tricycles known as "the ladies' hobbies."

PEDALS AND BRAKES

\mathcal{A}fter steering had been discovered, pedals were next. But it took almost 40 years before a young French mechanic, Ernest Michaux, added a system to the front wheels which, albeit rudimentarily, allowed

people to propel a Draisine without pushing their feet against the ground.

In 1855, Michaux first tried a lever hooked onto the wheel, to be operated with the arms, but the system was a failure due to its shaky balance and structural weakness. Then came a much better idea: He attached two rods to the front wheel, with two big nails on the ends (later replaced by a bent tube) on which to rest the feet. It took at least three days of trials and crashes to prove it was possible to ride without bracing one's feet against the ground. The pedal was born.

It was not until March 1861, however, that Ernest Michaux and his father (who as a young man had patented a road locomotive) officially presented their vehicle, called the Michaudine, in Paris. The interest of enthusiasts was not slow in coming: almost 150 Michaudines were sold the next year, and by 1865 orders had reached 400, not just from all over France but also from Great Britain. True success came in 1867, when, at the Paris Universal Exposition, the Michaux pair presented a new line of models, made entirely of wood, that won the hearts of the French nobility. The Prince de Sagan ordered a rosewood and bronze model which cost 1,800 francs (compared to 150 or 200 francs for standard models). On the exhibition bicycle, for the first time, was applied a little iron pad, operated by a cable, which rubbed against the rear wheel and slowed it down. The brake, too, was a Michaux invention.

The fashion of owning a bicycle so irresistibly set by the French nobility forced the Michaux pair to join up with two bankers and found the first true bicycle company: Michaux et Cie (which later became Compagnie Parisienne), funded with a capitalization of 100,000 francs, 500 employees, and several steam-powered woodworking machines.

THE CLUBS

\mathcal{A}s often happens, the spreading bicycle trend generated clubs of enthusiasts, who organized the first races. These races were associated with country festivals, and they were a cross between a sporting event and an acrobatic display. The programs called for speed races, slow races, and obstacle races—the latter a kind of two-wheeled cross-country free-for-all over ditches, hedges, or walls.

The influence of horse racing was obvious; racers were required to wear riding jerseys and a jockey's cap, not to mention riding boots. There were also handicaps: champions had to haul an extra 2.2 to 11 pounds on their bicycles (depending on their previous victories) to make sure all entrants had a fair shot. By the end of the year, on November 1, 1868, women were riding in their first race in the Hippodrome du Parc Bordelais.

A considerable boost to bike racing certainly came from the specialized newspapers founded during this period. But the bug and the business of racing quickly caught on even among the non-specialized

press: on November 7, 1869, *Le petit journal* organized the first long-distance race. It ran 75.6 miles from Paris to Rouen, with 1,000 francs for the winner. A field of 323 racers entered, including many women, although only 109 riders showed up for the start.

The race was won by James Moore in 10 hours and 34 minutes, a quarter of an hour ahead of France's Castera. The only woman to finish, registered as "Miss America" (clearly this was not an activity for a lady to boast about) arrived at the finish line in 23 hours and 20 minutes.

In Italy, the first bicycle races were held in Padua on July 25 and 26, 1869. Entrants rode wooden velocipedes in these races, conducted at the conclusion of the horse races organized in Vittorio Emmanuele Piazza, on a 1.2 mile track.

The first prize, a gold watch, went to Antonio Pozzo; Gaetano Testi won the next day. The following August 22, Paolo Selz won a track race held in Udine. Then, on February 2, 1870, the newly formed *Veloce Club Fiorentino* organized the first Italian road race, open to "racers of all nations." It was 19.8 miles long, from Florence to Pistoia, and was won in 2 hours and 12 minutes by American Van Heste Rynner, who received a gold medal and a revolver as prizes. Edoardo Ancilliotti, the first Italian to come in, arrived 14 minutes later, taking fourth place.

The Veloce Club of Milan was founded on March 17, 1870. Initially it only organized Sunday touring excursions. Then came its

first race, almost a year later on January 8, 1871. Giuseppe Pasta (who became one of Italy's premier international racers) this tour of the Milan ramparts, a route of 6.6 miles. A few months later, Stefano Johnson (future founder of the Touring Club) won the Porta Venezia-Porta Tenaglia speed race, a 2.1 mile course.

MORE INNOVATIONS

\mathcal{T}hanks to the invention of the pedal and the brake, the Michaux won great recognition for revolutionizing the velocipede. But their bicycles were so bulky, rigid, and heavy that it was impossible to go faster than 7.2 miles per hour.

As early as 1865, when bicycles really began to catch on, builders had begun giving their imaginations free rein in the effort to make bikes lighter and faster. Patent offices were swamped with applications from craftsmen, mechanics, and inventors (mostly from France, England, and the United States), all claiming more or less minimal innovations. Let one figure stand for all to indicate the passion inspired by the new vehicle: From 1865 to the beginning of 1900, over 1,600 patents were taken out on two-wheelers.

Builders devoted a major portion of their efforts to lightening the bike. In 1868 an English firm specializing in sewing machines, Coventry Sewing Machine Co., produced the first bicycle with a solid iron frame. A few months later Ernest Meyer, a German mechanic who

had a workshop in Paris, made a frame from gas pipes, reducing the bicycle's weight drastically.

At almost the same time, Parisian Jules Truffault built the first hollow metal wheels and replaced the front fork (still the heaviest part) with two cavalry scabbards.

These modifications, small and large, slowly pared the bicycle down to 30.8 pounds, and then to 22 pounds, making it both faster and safer. At the same time, the greater innovations emerged. In 1869, Jean Suriray of Melun, the owner of a steam-powered sawmill, fitted his bicycle's wheel hubs with ball bearings (patented in the U.S. in 1861); a few months later, he made the first leather saddle.

In November of 1869—which we can see turned out to be a banner year for two-wheelers—the first *Exposition du Vélocipède* was held in Paris, with 19 builders participating. For this occasion the Compagnie Parisienne (successor of the Michaux company) published the first newspaper ads selling bicycles, at prices ranging from 190 francs for the bare-bones model to more than 700 for the deluxe model featuring bronze parts and "extremely new systems offered exclusively by the company."

THE COMPETITIVE SPIRIT

\mathcal{I}nnovations that made bicycles faster—and cheaper, thanks to the advent of mass production—lent new impetus to cycle racing.

Along with more traditional races, the first national championships were held in London in 1880. They were organized by the Bicycle Union and offered races of four distances: 1, 5, 25, and 50 miles.

A year later, the *Union Vélocipédique de France* was born, announcing the first French national championships, to be held on the beaten-earth track in Place du Carrousel in Paris, with separate races for professionals and amateurs.

Then, in 1885, the French invented the national track endurance championship, over a distance of 60 miles. The first winner was Jean Budois, who covered the distance in 4 hours and 41 minutes, a more than respectable time, when you consider the means available to him.

Meanwhile in Italy, the *Unione Velocipedistica Italiana* was founded in Turin in 1884, and on August 24 the Italian Speed Championships were held on a circuit set up in the old Piazza d'Armi. The organizer was the *Veloce Club Torinese*, under the auspices of the *Esposizione Generale Italiana*.

The championship title, *Campione dei Veloci Club Italiani*, went to Giuseppe Loretz of Milan, who received as his prize an "artistic and precious gold-plated bronze Cup of considerable value, weighing 158.5 pounds, offered by His Royal Highness Prince Amedeo of Savoy."

\mathcal{B}y now the two-wheeler was really only needed two things to become the modern bicycle: the chain and the pneumatic tire.

The chain was first designed by Leonardo da Vinci in 1482 and was already used in various types of mechanical equipment by the late 1700s. André Guilmet, a Parisian watchmaker with a passion for bikes, had tried using a chain in bicycles as early as 1868, but apparently without success.

In fact, Guilmet's claim as the first to try this combination is not universally accepted. There are many contenders for the patent on the chain, and practically every country claimed the invention. Among the claimants were one Shergold in the U.S. (1876) and Lawson in Great Britain (1879). In any case, by the end of the 1870s the chain was becoming well accepted. First, the wheel positions were "reversed," with the smaller one in front, and the big one, with the chain, in back. Then, for safety and better handling, the two wheels evolved to become the same size.

In Italy, the first to build a bicycle with a chain transmission was the craftsman Costantino Vianzone of Turin, the father of the Vianzone brothers who would go on to found one of Italy's most important bicycle factories. In 1884, Costantino built a bicycle with rope tires and a wooden frame onto which he attached a chain and wheels of the same diameter.

A year later, the young Milanese craftsman Edoardo Bianchi built his first *bicicletto* with a cross-shaped frame and two perfectly identical wheels. The care he took with the finishing touches and the precision of construction soon brought Bianchi to the attention of enthusiasts in Milan and eventually all over Italy.

In the early 1880s, the normal *bicicletto* had a so-called cross frame: the tube that ran from the seat to the pedal mechanism was intersected, halfway down, by the tube joining the rear wheel to the handlebars. Though elegant and sleek, this design lacked adequate strength and rigidity.

In November 1886 the Englishman Thomas Humber presented the first "diamond" frame at the International Velocipede Exhibition in London. This configuration—roughly resembling that of a modern men's bicycle—was known as the Safety frame because it offered the rider greater stability.

THE TIRE

The modern bicycle was now only missing the pneumatic tire. Rubber had been discovered and used industrially for decades, but not until 1839 did the American chemist Charles Goodyear discover the vulcanization process, which made rubber elastic by melting and combining it with chemicals.

In 1869, an American named Bradford nailed a thick strip of solid rubber to his wheels to reduce vibrations and jolts from the road. The results were excellent, but since rubber tends to melt in summer and crack in winter, other materials also underwent experimentation. Strips of cloth, leather, or rope were either nailed or glued on wheels to test their effect.

But it was rubber that carried the day. By the end of that remarkable year of 1869, the English builder Beck had introduced a bicycle with solid rubber tires associated with a strip of rubberized canvas by which they could be nailed to the wooden rims. However crude the system sounds, the result was a resounding success.

Late 1870 saw the advent of the first U-section iron rims built to retain rubber strips. Meanwhile, there were many attempts to find more suitable rubber mixtures; some people tried a type that was hard on the inside and springy on the outside, others a tube of very hard rubber with a spongy core. The real revolution, however, did not arrive until 1888. John Boyd Dunlop, a Scottish veterinarian transplanted to Ireland receives the credit for this revolution.

The Dunlop adventure actually started in 1887, when the good doctor watched his ten-year-old son struggling down muddy roads on a tricycle with solid-rubber tires. Dunlop tried a number of ways to give the wheel more bounce, until finally he wrapped the rim with a tube of vulcanized rubber inflated to a low pressure with a glass syringe.

On November 18, 1889, Dunlop Pneumatic Tyre Co., Ltd. was founded in Dublin, with a capitalization of 25,000 pounds sterling: the veterinarian, holding 29.9% of the shares, became Chairman of the Board of a company that would achieve immense success within just a few years. Of course, it could rely on an enormous clientele.

In fact, by this time, there were over a million cyclists, most of them concentrated in a few countries: 500,000 in Great Britain and Ireland, 250,000 in France, 150,000 in Germany, 50,000 in Italy, and about the same number in Belgium.

But the story of the tire does not end with Dunlop. Barely two years later, in 1891, Edouard Michelin arrived on the scene, the owner of a small company specializing in the production of rubber articles for industry. After numerous failures, he originated the removable pneumatic tire, which used two steel wires to keep the outer cover fastened to the rim.

Michelin experienced a stroke of luck when he introduced his new tires at the most important cycling event of 1891, the grueling 724.8 mile Paris-Brest-Paris race.

The third major figure in the development of the bicycle tire gave the tire its definitive form. Giovanni Battista Pirelli, a Milanese industrialist, had operated a rubber-working company since 1872. In 1892, he built the first "Milan pneumatic tire," with the so-called beaded rim still used today. The tire is held tight in grooves around the wheel rim by the pressure in the inner tube.

All the essential components of the bicycle were now complete and, as though in formal acknowledgment of the occasion, Italy finally adopted its modern form of the name, *bicicletta*.

ROAD RACING

The popularity of the bicycle gained immense momentum from a group of now legendary and almost incredible road races. These represented the only real way of proving that the bicycle was not just a toy for city use, but also an effective means of transportation in its own right.

In 1903 Desgrange organized the first Tour de France, a total distance of 1,455.6 miles divided into six stages. Eighty-nine participants signed up, 64 started, and only 18 finished. The winner was Maurice Garin, in a total of 94 hours and 32 minutes. An Italian named Muller came in fourth about 5 hours later.

The Tour proved to be an immediate success because it had something for everyone. The division into stages allowed the newspapers to organize their reporters' assignments and keep attention focused on the event for several days. The public could watch the leaders finish, regroup in a pack, and start off again. Bike builders had a great opportunity for self-promotion. And finally, racers could pace themselves more effectively.

Italy's first long-distance race was organized by the paper *La*

Bicicletta on May 14, 1892. Riders started in Milan, and finished—318 miles later—in Turin. Enrico Sauli won in 26 hours and 25 minutes. Several other classic races were founded early in the century, such as Milan-Turin (1903) and Milan-San Remo (1907). But the greatest of the Italian races was first held in May 1909, when the *Gazzetta dello Sport* organized the first Giro d'Italia. The great Milanese newspaper *Il Corriere della Sera* put up a first prize of three thousand lire (equivalent, according to Italian government statistics, to ten million 1992 lire—about $11,800). The race covered 1,468.8 miles, starting in Milan with stages finishing in Bologna, Chieti, Naples, Rome, Florence, Genoa, Turin, and Milan. The 127 racers included many Frenchmen, and the winner was Luigi Ganna, followed by Galetti and Rossignoli.

PROHIBITIONS AND TAXES

The great races finally succeeded in establishing the bicycle as a common medium of transportation, and its use spread enormously—notwithstanding all the prohibitions, restrictions, and taxes imposed by various governments.

The Municipality of Milan levied a tax of 12 lire, an amount just short of a modern L. 50,000 ($40). At this time, a Bianchi bike cost about 130 lire, a Peugeot more than 200, and a Raleigh with all accessories as much as 600 lire. A few years later came the requirement for a rider's license (cost: 15 lire) and a certificate of road worthiness issued

by a municipal commission "after testing, or upon attestation from cycling societies designated by the city council."

Nothing seemed likely to stop the spread of the bicycle: There were already 605,000 in Italy in 1909, and 1,225,000 in 1914. The publisher Hoepli of Milan put out multiple printings of a book entitled *How Should I Behave?*, dedicated to cycling etiquette. It offered complete advice on what to wear (the hat should be of light-colored soft felt; socks should be long and woolen), road traffic, and, of course, encounters with ladies, including the correct hand-to-hat salute.

Poets like Filippo Tommaso Marinetti, the father of the Futurist movement, sang the bicycle's praises, while the painters Boccioni and Toulouse-Lautrec revealed its visual allure. Almost alone, Cesare Lombroso, the most famous criminologist of the age, fulminated against the bicycle, calling it "the fastest mode of transportation down the road to crime, as the pedal passion leads to theft, fraud, and banditry."

Fortunately, nobody listened to him, and the use of two-wheelers continued to spread. The bicycle performed not only in competition and touring (this was the golden age of the Touring Club, founded in 1895 in Milan), but also in work and service. At the turn of the century firemen were already using bicycles for emergency duty in petrochemical plants.

\mathcal{D}ifficult as it may be to imagine a bicycle as an instrument of war, it was the military supply industry above all that discovered the utility of bicycles for the army. The first service to use bicycles systematically was the Royal Carabinieri, who adopted the Costa model in 1896—a bicycle specially built for the armed forces, that could fold up and was equipped with straps that allowed it to be slung over the shoulder.

The first bicycle-mounted carabinieri were armed with a Model 91 cavalry musket, which they carried slung across the back while pedaling and shouldered when they carried the bicycle.

In June 1898, the Italian Army adopted a special badge for cyclists (embroidered with red wool for enlisted men and gold and silver for the officers) which is still worn today. Early in the century, a specialized bicycle-mounted infantry company was formed to serve in Sardinia. Through an agreement with the Ministry of Finance, it secured an exemption from the bike tax for military bicycles, provided they bore a plate with the words "Military Service" inscribed below a crown.

The military sector also contributed some bicycle innovations of its own. In 1908, Infantry Captain Carraro invented a new type of folding bike weighing 31 pounds, which was named after him. But the biggest leap forward came in 1911, when the Army called on companies to bid for a contract to supply a new bicycle for 12 battalions of the

light infantry known as *Bersaglieri*. The contract was won by Edoardo Bianchi, who began in 1912 to build the Bianchi Patented Military Bicycle with an articulated frame and solid wheels. Painted gray-green, it was widely used by the *Bersaglieri* in the First World War. The Model 12 (built, appropriately enough, in 1912) was replaced by the Model 23 and Model 25, each incorporating modifications and improvements to adapt bicycles better to military needs—for example, by outfitting them to carry machine guns. Eventually, the bicycle ceded ground to the motorcycle. But it remained in service with the Army until World War II, albeit reduced by then to a medium for transportation on bases or along city streets.

THE BICYCLE TODAY

The evolution of the bicycle continues today, as it did when first the motorcycle and then the automobile gained the upper hand, relegating the bike to the sidelines.

It is still the only medium of transportation truly built to the measure of man (or woman). And today, thanks to the rediscovery of such fundamental values as health, ecology, and pleasure in the company of others, the bicycle seems on the verge of a triumphant comeback.

Index of Bicycles